I HEAR A
VOICE CALLING

I HEAR A VOICE CALLING

A Bluegrass Memoir Gene Lowinger

University of Illinois Press *Urbana and Chicago*

© 2009 by the Board of Trustees
of the University of Illinois
All rights reserved
Manufactured in the United States of America
1 2 3 4 5 C P 5 4 3 2 1
∞ This book is printed on acid-free paper.

All photos, unless otherwise noted, were taken
by and copyrighted by Gene Lowinger.

LIBRARY OF CONGRESS CATALOGING-IN-PUBLICATION DATA
Lowinger, Gene.
I hear a voice calling : a bluegrass memoir / Gene Lowinger.
Includes index.
ISBN 978-0-252-03475-6 (cloth : alk. paper)
ISBN 978-0-252-07663-3 (pbk. : alk. paper)
1. Lowinger, Gene.
2. Fiddlers—United States—Biography.
3. Bluegrass musicians—United States—Biography.
I. Title.
ML418.L78A3 2009
787.2'1642092—dc22 [B] 2009001003

THIS WORK IS DEDICATED TO *the memory of Bill Monroe and Professor Raphael Bronstein, to Ariana Bronne, to Ben Fernandez and Mario Cabrera (wherever you may be), and to my friend John C.*

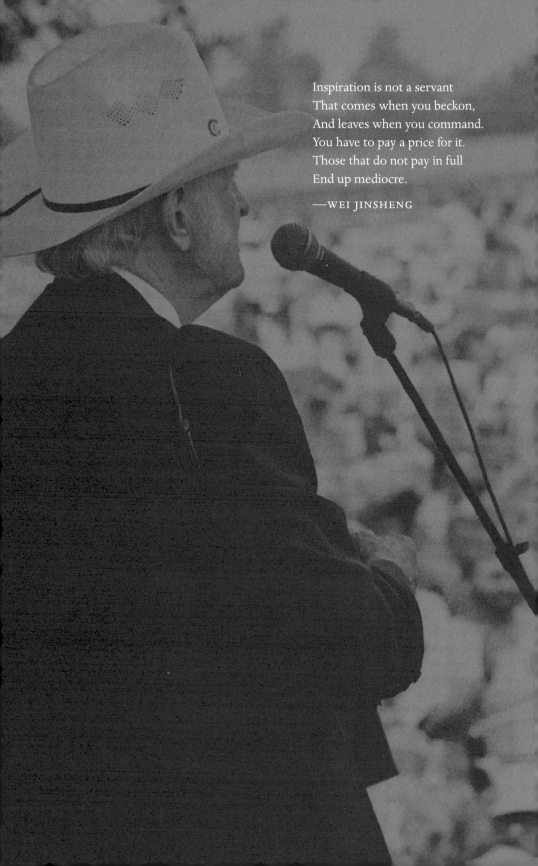

Inspiration is not a servant
That comes when you beckon,
And leaves when you command.
You have to pay a price for it.
Those that do not pay in full
End up mediocre.

—WEI JINSHENG

CONTENTS

ACKNOWLEDGMENTS

I am indebted to Tom Ewing for his meticulous efforts at keeping logs and journals, for his research efforts, and for generously providing me with dates and names that are long lost to my memory; Laurie Matheson for her encouragement and direction; and Lynn Lipton for reading and critiquing the original drafts.

I HEAR A
VOICE CALLING

INTRODUCTION

This is a memoir. It's a personal and subjective statement about my music, my photography, and the people who believed in me enough to invest their time and energy into my development, and it is especially about Bill Monroe. I felt a deep stirring to do the photos of Bill when I saw him again, after many years, at a performance at Sunset Park in West Grove, Pennsylvania, on July 15, 1991. I wanted to pay homage to the man who gave me my first big break in life and who taught me through his music what I was to learn again and again through other forms of music and creative adventures and from other teachers and mentors. I knew that as his former fiddler, I had a bond with him that would put him at ease with me. He allowed me behind his public persona to shoot private, personal moments, so that I could show the Bill Monroe that his audience never saw.

I dearly wish I had been a photographer (but I wasn't), or at least had a camera with me (but I didn't), during the time that he was teaching me his music. As a result, the range of photographs in this collection is somewhat limited. The early pictures from the 1960s were taken with a thirty-five-millimeter camera that, by today's standards, would be considered a point-and-shoot camera, and I had no experience or training in photography at that time. The negatives,

slides, and prints were not stored with any thought to longevity. Nevertheless, I feel that some of these pictures should be included because, despite their mediocre quality, they help to put this story into perspective.

Obviously, I did not take the photographs in which I appear. Most of them were given to me over the years, and in a number of cases the identity of the photographer has faded into the dim recesses of my aging memory. The pictures I took of Monroe in the early 1990s while traveling with him were shot with one of three cameras: a Leica M6 rangefinder, in which I used exclusively black-and-white print film (Fuji Neopan 400 or 1600); a Nikon 8008 SLR, which I loaded with either black-and-white print film or Kodachrome slide film, and a Nikon FM2 SLR, which was my backup camera. I had a "wet" darkroom at the time and spent many hours developing film and making prints from the negatives. When I first conceived of this book in 1994, I scanned those prints into my computer on a flatbed scanner. As time went by and technology progressed by leaps and bounds, I joined the digital age. All the photographs in this collection that I shot were rescanned into my computer using a dedicated Nikon film/slide scanner in 2007.

The original challenge of this project was to get photos that, while being up-close and personal, would be as nonintrusive as possible. I wanted to portray private moments in a sensitive way, which often required no flash and a quiet camera that would not distract Bill while I shot hundreds of frames. There were times when I'm sure he wondered why I needed to take so many pictures. I knew these were opportunities and situations that wouldn't come my way again, so I bracketed like crazy and shot from every angle I could twist my body into.

The performance shots were the easiest to take. For those I could use a flash, and the sound of my SLR wouldn't be distracting because the music, especially the banjo, would cover any noise the camera made. For those situations, the Nikon SLRs were ideal. The challenge in the performance pictures was to make them "real" and natural-looking without the artificial glare of the flash. To accomplish that, I unashamedly used my high-quality computer software (and a small measure of skill, intuition, and talent). An intimate understanding of Bill and his songs was a definite advantage in being able to anticipate facial expressions and hand gestures he usually made with the mandolin while he played and sang. He could change the sound of his voice instantly to fit the words he sang, and he used body language to create the character of phrases, especially when he moved his voice from full tone to falsetto. A pose could fly by in an

instant, and I had to be constantly on my toes to catch that special moment. If the camera was hanging from my neck, by the time I got it up to my eye, got the shot composed, the focus and exposure set, and the shutter pressed, the special moment was long gone. When I was in front of the stage taking pictures, the camera was *always* up, and I sang every song along with him so that I could feel the rise and fall of tension in the melody and the flow of words.

Taking performance photos may look like fun to someone in the audience. For the photographer it is fun, but it's definitely exhausting work. Finding the right angle for a shot is difficult because singers get in close to the microphone, making straight-on shots impossible. Often a shot from the side would have a distracting element in the background that appeared to be a microphone boom or neck of a banjo growing out of Bill's head. There is also the added frustration of having to deal with people in the audience who had an attitude about me popping up in front of them to get the shots—they had a hell of a nerve—and they often told me to get out of the way. Bill was always aware of me out there taking pictures. It was wonderful shooting him because he had a sixth sense of just when the shutter would click and the flash would fire. He literally gave me many shots. And if he sensed that I was having trouble with people in the audience, in between songs he'd say, "There's a fella here taking pictures that I want to introduce. He used to play fiddle with me on the Grand Ole Opry." And after that there never was a problem. Except for me, of course, because then he'd want me to come on stage and play a tune with him. That was terribly distracting for me; it broke my rhythm and concentration, and it usually took me a couple of songs to calm down after I had played and get back into the flow of shooting. When Bill performed on the Opry he usually did two or three songs on his segment of the evening's performance, interspersed with other performers, so I either got the shots or not in a short space of time.

The more personal offstage shots were much more difficult technically and creatively. For these there was no more perfect camera than the Leica M6 and a wide-angle twenty-one-millimeter lens. Space in warmup rooms or on the bus is very confined, and other people were always in the way and often in the picture frame. And the lighting situations were at best challenging. A flash would have been exceptionally intrusive and distracting. And flashes create giant shadows, glares, and reflections off of windows, mirrors, and eyeglasses. Bill never wore his eyeglasses in performance, but he almost always did when he wasn't on stage. While it is possible to use a flash on a Leica, it's not an SLR, so there's no way to do through-the-lens metering, nor any convenient way to control

the flash output. But as camera lore goes, if you're shooting with a Leica M6, you should know enough to not need a flash. I used fast film to compensate for the ultra-slow shutter speeds that the low light on the bus required. And often I supported the camera on my knee to reduce shake. When I was on the road with Bill I drank a lot of coffee to be able to stay up all night, and caffeine did *not* contribute to a steady hand. Unlike an SLR, which has a shutter of metal leaves and goes *clunk* when you take a shot and then the motor whines as the film is advanced to the next frame, the Leica has a rubberized shutter that makes a very small click, and there's no motor to advance the film. It was ideally suited to the situation.

Some of the photos where shot in color and for this book converted to black and white. I much prefer black and white, except when I'm taking scenic or vacation pictures in exotic locales. We see the world around us in color every day. Black and white is an abstraction of reality. When anyone looks at a photograph, the first thing the eye will register is a brilliant or distracting color and that draws the viewer's attention away from the subject of the picture, unless of course the primary subject of the photo *is* the color. When I work in black and white, I have much more control over the viewer's attention. I can direct the seeing eye more easily with subtle tones and graphic elements of the picture that would be overshadowed by color. I was surprised a number of times, after I made the conversions from color to black and white ("grayscale," in modern parlance), by how much more powerful the shots were. I have noted which photos were converted. Many of the historical photos that were taken as snapshots and did not stand up well over time were originally in color and became much stronger pictures by removal of the discolored and fading nonarchival dyes used in the photo-printing process.

As I wrote this account to accompany the photographs, many times I wished that I had kept a journal of my days with Monroe, or at least a log of the dates we played, but once again, I didn't, and it was difficult to dig back over forty years to remember some of the details. The photos of the various artists and the stories about them are presented to give credit to those musicians who had a powerful influence on me when I was honing my skills as a bluegrass player, and to those who deeply impressed me with their openness and generosity upon my return to the music twenty-five years later. This is not meant to be a collection of photos of who was, or who is, who in bluegrass music.

I have been blessed to have several mentors who were exceptionally patient with me—Bill Monroe was the first, Professor Raphael Bronstein and

his daughter Ariana Bronne were my classical violin teachers, Mario Cabrera was my photography guide, and Ben Fernandez was a generous facilitator. The model Bill set for me, right from the first personal contact I had with him, remained important to me long after I moved on from his band. Having been a Bluegrass Boy has always been an honor and a privilege. Having been a Monroe fiddler gave me the opportunity to learn invaluable lessons, musical and otherwise, that have stayed with me through my life. Bill was the first person who showed me that it is okay to dream and to pursue that dream and stay true to its course through lean and fat times. And he showed me that there is indeed a pot of gold at the end of the rainbow—not necessarily material, but certainly spiritual—and it is worth the effort to work hard.

In the text that follows, wherever there is a number enclosed in parentheses, it refers to the appropriate number of the corresponding photograph.

Now, on with the story.

CHAPTER **I**

Beginnings, 1942–62

Hindsight is indeed 20/20. Looking back, my journey seems to have unfolded inevitably. I was born into an upper-middle-class Jewish family of Eastern European origin that had been living in the New York City area for a few generations. Bluegrass was definitely not the music I heard growing up. It wasn't available, in any form, in the community where I lived. It wasn't in my blood, mind, heart, or spirit. Yet the first time I heard it, I was deeply moved. And the first time I saw Bill Monroe perform, my creative vision started to become clearer.

Much has been written about how bluegrass has become its own genre of indigenous American music. It has been developed by corporate types into a marketing operation, and organizations have sprouted to carry the banner of the defenders of the faithful. Performers vie for the honor of carrying the torch supposedly handed down by the man that began it all with his inspiration for the sounds that were swimming around in his head—an amalgamation of the music he heard around him as a child, with a dash of individual ingenuity that made it a unique sound.

This is a personal account of my experiences with Bill Monroe and after, covering more than thirty years, from the first time I heard him perform in

1963 through the last time I sat with him backstage at the new Grand Ole Opry House outside Nashville, and beyond. If someone had told me, when I first started working for Bill, that this was to be the beginning of a spiritual journey that would lay out the path for the rest of my life, I would have balked. I was a young buck looking to have fun, with no thoughts of what the future might hold.

I always had a penchant for music. When I was a child I listened to all kinds of music—early rock 'n' roll, Jewish songs my maternal grandfather sang to me, classical music, show tunes my mom and dad listened to. Anything that was music, I loved. I played air guitar along with Bill Halley and the Comets as they sang "Rock around the Clock," I played air violin along with a recording, given to me by a cousin, of Tchaikovsky's Violin Concerto, and I sang duets with cantorial renditions of Jan Pierce and Richard Tucker. My parents were active in our local synagogue and sang in the members' choir every Friday night, and I sat next to my father in the tenor section.

When I was nine years old, I had a chance to play a quarter-sized violin, and I thought that I had made the greatest discovery in the world when I figured out that I could change the pitch of a note by putting a finger down on a string as I dragged the bow across it. I loved the idea of making music but hated to practice, so my first attempt was short-lived. In junior high school, where I was always hanging around the band room and eyeing the instruments, the band teacher asked me if I wanted to learn how to play string bass (he needed someone to at least hold up the instrument in the concert band), and I eagerly said yes. He gave me a beginner's instruction book, an instrument, and a corner of the music room to practice in for one period a day, and I went at it, this time with more fervor. My dad, having been a leader of a band in the late 1920s, saw some potential in me learning the bass—I could play in a dance band and actually make some money with music—so he invested in an instrument and found a private teacher for me. And my performing career began. I played in bands as a junior and senior in high school and during my first year in college.

In my last year of high school, while sitting in an art class with music piped through the PA while we worked, I heard the Kingston Trio sing "Hang Down Your Head Tom Dooley." I heard the twang of the five-string banjo. Now, *that* was an instrument I could really get into. I bought myself a fifteen-dollar banjo and the Pete Seeger banjo instruction book and set to work learning how to read banjo tablature. I searched out the recordings Seeger recommended. What

I couldn't figure out from the book or the music examples in it, I learned by listening to recordings. Copying what I heard was much easier than trying to guess at what was being described in words, so I bought lots of recordings featuring the banjo. I quickly graduated to a Vega five-string banjo, but not the long-necked Pete Seeger version. Three recordings were seminal for me: an eclectic Folkways collection, *Mountain Music Bluegrass Style; Foggy Mountain Banjo*, recorded by Lester Flatt and Earl Scruggs; and a recording with the New York banjo virtuosos Eric Weissberg (of "Dueling Banjos" fame), Dick Weissman, and Marshal Brickman. I was mystified by how one person could play so many notes so fast. When I heard Earl Scruggs play his instrumental "Ground Speed," I decided that that was how I wanted to play, and I set to it.

In 1962, I was a sophomore at Rutgers University and a very active folkie. I had a band—a trio called the Lonesome Travelers—that got together every week to put together arrangements of songs that we had heard performed by the Limelighters, the Weavers, the Kingston Trio, the Tarriers, and the New Christy Minstrel Singers. We performed at local coffee houses that had "hootenannies"—the precursor of open-mic nights. I had a lot of difficulty getting anything like a bluegrass sound out of the Vega banjo, so I placed an order for a brand-new Gibson Mastertone and told anyone who would listen that I was getting it. It took months to arrive, and there was considerable doubt about my veracity among my fellow folkies. The day I got a call from the music shop to tell me that the banjo had come in, I cut classes for the rest of the afternoon and rushed to the store. When I opened the case, the chrome plating, the ivory inlays, and the pink plush lining in the case dazzled me. The salesman, whom I had been pestering for several months while waiting for the instrument, asked me to play something. I was amazed at how heavy it was, and I was so nervous that my fingers trembled as I tried to pluck the strings. What I really wanted to do was get back to the student lounge where a group of us pre-hippies met every day to sing our songs of protest and outrage at the establishment. These were the people to whom I needed to show this instrument, so they could get an idea of what a serious banjo looked and sounded like—none of that plinky-plinky, scratchy-scratchy stuff that they listened to on those folk albums.

There was an amateur folk-music night at a local high school where my band appeared; also at that concert there was a New York City bluegrass band called the Bluegrass Straphangers. When they performed, they brought the house down. I realized that if I was ever going to learn to play bluegrass banjo, I had

to hang around folk places in New York, especially the famous Washington Square Park in Greenwich Village. Every Sunday afternoon, when the weather was warm enough, I would pack up my banjo, jump on a bus into New York, and head to the central fountain in Washington Square, around which were arrayed the best and the worst players, the newest and the most experienced musicians of the New York folk-music scene—and best of all, crowds gathered around each performer trying to be the reincarnation of Woody Guthrie, the Weavers, the Kingston Trio, or Earl Scruggs. I was most attracted to the bluegrass bands, which drew the largest crowds. I so wanted to be a player in one of them, but the banjo players were so adept at Scruggs-style banjo that I couldn't come close to their technique. So I watched and listened and learned. I went home and practiced for hours each day—forget the term papers for school—and went back the next Sunday to Greenwich Village to try to keep up with the players, only to find more and more banjo players each week, all of whom played better every time I heard them. Bluegrass bands were all over the square—they all had guitars, mandolins, banjos, and basses, and they were all good. But the one instrument lacking was a fiddle. If I wanted to get noticed, if I wanted to be the center of attention, I needed to play fiddle.

As I had done with the banjo, I bought myself a fifteen-dollar Stradivarius (copy) at a local music shop and started to listen intently to the fiddlers on the recordings I already owned. I had seen photos in instruction books about how to hold the bow and the instrument, but I developed many bad habits that continued through my bluegrass days with Monroe. When I got to Nashville I discovered that almost every fiddler there held the bow with the thumb of the right hand under the frog, not tucked between the bow stick and horsehair. I never changed my bow grip after having learned the traditional violin position. I assumed that the classical grip had evolved over a period of three hundred years, and that there must have been a good reason for holding the bow that way. Later, when I began my violin studies, I realized the advantages in flexibility and bow control that the hand position afforded. I struggled through the first weeks of fiddling with great difficulty, until I realized that if I took a 33 rpm record and played it at the 16 rpm, the notes would go half as fast and just about an octave lower. That was the solution for me. I stayed away from Washington Square, bought some square-dance recordings by Tommy Jackson, and learned a few fiddle tunes—all in the key of A or D.

When next I went to Greenwich Village I was carrying my fiddle case. At the first bluegrass band around the square that I came to, I pushed my way to the

front and took out my fiddle. When the guitar player asked me what I wanted to play, I said, "Bile 'em Cabbage Down," and off I went on a tear. The crowd came, and I loved it. I felt like I had arrived. The problem was that after three or four tunes, my repertoire was exhausted, so I packed up the fiddle, found another band, and played the same tunes. And again . . . and again. I was so buzzed by the time I went home that I was determined to learn more tunes for the next week, and the week after that, and the week after that. I developed a repertoire of square-dance tunes. Bluegrass, I was to learn, was much more than sawing dance tunes on the strings. But for then, it was good enough to get noticed.

As part of the folk-music craze of the 1960s, coffee houses in Greenwich Village began to engage folk acts and draw crowds on the weekends. One bar, Gerde's Folk City on West Fourth Street, had become a mecca for folk enthusiasts and *the* place to play in New York. Every Monday night a hootenanny would be put on; people would begin to arrive at seven to get their name on the list to begin playing at ten. The first time I went on a Monday night, I saw that I was never going to get on the list, but I hung around in the basement where performers warmed up and had impromptu jams. I met Roger Sprung, and he asked me to get on stage with him. I was thrilled. Roger was the first New York City person that I know of to go south to learn the music. What he brought back he showed to many others, such as Eric Weissberg of the Tarriers and Bob Yellin of the Greenbriar Boys. Roger was, more than anyone else, responsible for the rise of bluegrass banjo playing in New York City. But when I got on stage to play with him, I was so nervous that I could barely keep the bow on the strings. Didn't matter. Roger and I generated an intensity that lit the audience. And I went back every week for months just to get up with Roger and work out my jitters playing fiddle tunes I'd just learned from Tommy Jackson square-dance recordings.

My music playing was severely limited because I could play only in three keys—A, D, and G. Bluegrass singers have an annoying habit of singing in keys that are convenient for their voices and not particularly for the fiddle, like B-flat, B, E, and F. So I couldn't take solos on songs in those keys. And although I listened to many different bands on recordings, the only performers I saw live were fiddle-less. The Greenbriar Boys—a hot city bluegrass band that performed regularly at Gerde's Folk City—was a trio (guitar, banjo, and mandolin). The Dillards were a much-anticipated band that performed in Gerde's, but with no fiddle. The only band I saw that had a fiddle was a trio that performed old-time music—the New Lost City Ramblers—so they didn't really count. I

played bluegrass with a few local New Jersey friends, but had only my intuition to go on while trying to figure out how to do things on the fiddle. And then I heard that a fiddler who had recorded on the *Mountain Music Bluegrass Style* album lived in suburban New Jersey and worked as a research mathematician for Bell Labs. Tex (Ben, to those who knew him as a math whiz) Logan, who had played fiddle with Wilma Lee and Stoney Cooper and was a good friend of Bill Monroe's, was just a few miles away, hiding out in his basement with oscilloscopes and other arcane electronics while I was twisting my brains and fingers trying to play a style of fiddle music that I had been told over and over again no northern city boy could really get. So the New Jersey band I was currently playing with went to visit him. He was kind to us, but much too busy developing computer languages and such for Bell Labs to be bothered with us. But I had made a contact that was to pay off big time in a little over a year.

The musicians in Washington Square and around New York City were very cliquish. I fell in with one group and formed a band, the Down State Rebels, and there was another group centered around David Grisman, who was at that time a protegé of Ralph Rinzler, of Greenbriar Boys fame. We all played at one time or another on those Monday-night jams at Gerde's, and it was at one of those sessions that the Down State Rebels were heard and approached by a representative of Bobby Darin (of "Splish Splash I Was Takin' a Bath" fame). He wanted to record us. We strutted around like bantam roosters. We had arrived! I still was severely limited by the choice of keys in which I could play, the group was made of marginally acceptable singers, and our perception of indigenous southern music was acutely distorted. After hearing us, Darin offered us a contract, which was signed after much bickering among our parents. The session dates were set, and we worked hard on our repertoire to polish twelve bluegrassy-folksy songs for recording. The sessions were rocky, and there was a great deal of tension between some band members and Darin. At one point during the first session, to relieve the tension, Darin came out of the control room and took a break with us. He sat at the piano and started into an intense blues rendition à la Jerry Lee Lewis. When we got back to playing, we all felt much more inspired, but to no avail. We were still New York City college kids. But record we did. And it went nowhere.

At this same time, David Grisman was bussing back and forth from New York City to Washington, D.C., to learn his music while sitting at the feet of Frank Wakefield and Red Allen. I was jealous, so I started hanging around David. Because of his influence, I began to listen earnestly to recordings of Bill

Monroe, especially his early recordings with the first, and arguably the best ever, bluegrass band of all time: Bill Monroe, mandolin, lead and high tenor singer; Lester Flatt, guitar and lead singer; Earl Scruggs, banjo and baritone voice; Chubby Wise, fiddle; and Cedric Rainwater, bass. Chubby's fiddling was tastefully hot, bluesy, swingy, and driving all at the same time. And he played in all those difficult keys! So I had to figure it out. I was spellbound by the sounds of Bill's music. I heard a voice calling me—the real-deal bluegrass.

CHAPTER **2**

Learning Bluegrass, 1963–65

S o there I was: a New York–area college kid from a middle-class suburban environment captivated by the sounds of a culture that bore no relation to anything I had ever experienced before. The only way to hear the music was either on the few bluegrass recordings that a small selection of record shops dared to stock, or from bands that performed in the New York area under the guise of "folk" groups. It wasn't enough.

I had heard that the "Grand Ole Opry" was broadcast from the AM radio station WSM in Nashville, and on a particular Saturday night, if the ionosphere was just right to bounce radio waves back to New Jersey, and I drove up to the top of a small mountain near where I lived, I could get lucky and hear a few snippets of real, live country music. And on a really lucky night, one of those snippets might be Bill Monroe or Lester Flatt and Earl Scruggs. There were other country radio shows broadcast from the South and Appalachia that I could catch on radio more easily. WWVA in Wheeling, West Virginia, broadcast its own version of the "Grand Ole Opry" on Saturday nights, and it was much easier to get on AM radio. That show had mainly local talent, but there were always guest appearances by Jimmy Martin, the Osborne Brothers, the Stanley Brothers, Earl Taylor, Red Allen, and others who played a hard-driving,

no-nonsense style of bluegrass. When the emcee talked to the guest artists, they would mention their road performances, and I began to hear names like New River Ranch in Rising Sun, Maryland, and Sunset Park in West Grove, Pennsylvania, both of which were outdoor country music parks, an institution at the time throughout the South. I checked a map and discovered that both of those places were about three-hour drives from my home. I could leave early Sunday morning, catch the shows, and be home by one or two the next morning.

The first time I ever went to Sunset Park was in 1962, to hear Lester Flatt, Earl Scruggs, and the Foggy Mountain Boys. That was before Grisman had turned me on to Monroe. I and some friends packed our instruments into a car and excitedly drove to West Grove without a clue as to what we would find when we got there. The format of the day was three bands playing round robin, each three times, with a half-hour break between shows. The first band—the house band—was Alex Campbell, Olabelle Reed, and the New River Boys, featuring Deacon Brumfield on dobro guitar, Sonny Miller on fiddle, and Ted Lundy on banjo. The second band was always a regional band that would balance out the show, depending upon who the star attraction was. If the main attraction was a country band, the regional band would be bluegrass. If the big name of the day happened to be a bluegrass star, the regional band would be country. Shows began at about 2:00 PM and usually ended at about 11:00 PM. During the course of the day, people gathered in the pasture in back of the stage for impromptu jam sessions, just like Washington Square—without the folk music and beatniks. These weekend warriors were rural folk who lived and breathed this music. Often Sonny Miller and Ted Lundy would come out back after their shows and continue to pick all afternoon. They were easily accessible to answer questions and willing to show us anything we'd seen them do on stage. It was from Sonny showing me licks and tricks that I began to get a real idea of how to put together a solo in a bluegrass tune and how to get the heavy offbeat accents with the bow that gave fiddle tunes such drive.

The early photos of the New River Boys (and girl) (1), Lester Flatt and Earl Scruggs (2), Bill Monroe (3), and Jimmy Martin (4) were taken with a Kodak thirty-five-millimeter camera. I had gone to Sunset Park to see and hear these legends of bluegrass perform and to learn the music. Taking pictures was way down on my list of priorities at the time; these were made as an afterthought. As I look at them now, they show me what a powerful tool the photograph can be for reviving memories of events of almost fifty years ago. The shot of Lester and Earl in front of their bus was originally a Kodachrome slide, which

is buried somewhere in my piles of memorabilia. This was made from a flatbed scan of a print I had made of that slide many years ago.

Rarely did a big-name performer come out to the pasture to pick, but they were always accessible to their fans, and we pestered them constantly with questions like, "How did you do that?" or "Why did you do it that way?" So I got a chance to talk informally with performers who today read like a veritable who's who of early bluegrass: Flatt and Scruggs (fiddler Paul Warren), Reno and Smiley (fiddler Mac Magaha), Jimmy Martin (with the legendary J. D. Crowe on banjo), the Stanley Brothers, Bill Monroe, Jim and Jesse McReynolds (fiddler Jimmy Buchanan), the Osborne Brothers, and Mac Wiseman.

A few miles down the road from West Grove, just across the Maryland border in Rising Sun, was another country music park, New River Ranch. They too had country music shows on Sundays. On a few rare occasions, both parks would feature star bluegrass attractions, and we had a hell of a time rushing back and forth from one to the other to catch every note of the masters that we could.

Inspired by our experiences at Sunset Park, a few of us decided that we needed to take a trip to Nashville to see the Grand Ole Opry. In September 1962, a quartet of us packed into a car and drove straight through the night to Nashville. We got tickets at the last minute for the Saturday-Night Opry, which was a small miracle, since it was Labor Day weekend (the Saturday-night shows were usually sold out months in advance). Before seeing the Opry we spent a few heady days roaming around the country music record shops on Broadway and out to the Music City section of town, where we thought we would be able to find lots of country music stars hanging around, waiting for fans like us. We drove out to the Starday recording studios on a whim and got to see Pete Drake overdubbing a pedal steel track. On the Opry that Saturday night we saw Jim and Jesse McReynolds with their band, the Virginia Boys, sponsored by the Martha White Flour Company (as were Lester Flatt and Earl Scruggs), and they sang theme songs to advertise Martha White products. Extolling the virtues of Martha White biscuits, in a bluegrass rendition, made a lasting impression on us.

Later that year, on December 8, 1962, Lester Flatt and Earl Scruggs, looking to capitalize on the surge in popularity of bluegrass as folk music, booked a concert at Carnegie Hall in New York City. On the bill with them was the legendary guitar virtuoso Merle Travis. The hall was packed, and I, along with the friends with whom I had gone to Nashville, had tenth-row seats. As the Flatt and Scruggs show progressed, people in the audience began calling out

for tunes like "Salty Dog Blues" and "Foggy Mountain Breakdown." My friends and I, just to show others in the audience how much more sophisticated and "in the know" we were, began yelling for the Martha White theme song. Unknown to us, the show was being taped for a future album. Many years later, when I told Lester that all the shouting was from me and my friends, he told me that Earl Scruggs whispered in his ear that they'd better do the theme song or else we'd never shut up. The theme song made it onto the album.

On February 8, 1963, through the vision of Ralph Rinzler, who booked occasional shows for Monroe, the Blue Grass Boys performed at New York University in Greenwich Village. This was a landmark concert for Bill. Rinzler wanted to introduce Monroe to the great potential of college audiences, and he wanted to open up the folk-oriented ears of a generation of college kids who cut their teeth on bluegrass thinking that Lester Flatt and Earl Scruggs were the pinnacle of bluegrass music, while its creator—the "father of bluegrass"—languished in obscurity. The concert was Bill's New York City coming-out party. He had been going through a periodic low point in his touring schedule and did not have a regular band, so Rinzler asked a Baltimore journeyman bluegrass guitarist, Jack Cooke (who in subsequent years worked as Ralph Stanley's bass player), if he and his banjo player, Del McCoury, would perform with Bill Monroe. Jack and Del joined Monroe and, with Kenny Baker on fiddle and the "Carolina Songbird" Bessie Lee Mauldin, Monroe's longtime girlfriend, on bass, formed the band for that night. The music was dynamite.

Bill went through his standard show, and when he came to the spot where he usually sang some solo numbers, someone in the audience asked for "Blue Moon of Kentucky." Bill was thrilled that the college kids knew his repertoire, and the requests came tumbling on stage for the rest of the performance. At one point Bill sang "Can't You Hear Me Calling." With Jack Cooke singing lead, the duet sizzled, and Bessie Lee impassively played bass while Bill and Jack sang "a million times I've loved you, Bess." In the second half of the show, Bill said, "Anybody got a request that they'd like to hear?" and all hell broke loose. Everyone was shouting out titles, and Bill couldn't hear one distinctly, so he just picked a tune he wanted to do, "Toy Heart." The only singing that Del McCoury did that night was to fill in the baritone harmony for trios such as "On and On" and in the gospel quartets. At that time, Del was a Pennsylvania logger and part-time banjo picker who had never thought much about singing.

The fiddling was spectacular. Kenny Baker's renditions of "Panhandle Country," "Orange Blossom Special" (a tune I was to grow sick of as I traveled with

Bill and played it over and over), "Grey Eagle," and his solos for "Mule Skinner Blues" and "Uncle Pen" had me entranced. After that night, I knew what work lay ahead of me: I had to learn every tune Monroe recorded and study every fiddle solo—note for note—that any of his various sidemen had ever recorded with him. I had it in my mind that I wanted to play fiddle for Monroe. I heard a voice calling me that night, and it was Monroe's. Initially it was his music that thrilled me, but once I began to work for him and he talked to me about his commitment to his music, his vision, dedication, and tenacity for his creation awed me. He showed me how important it is to stay true to my course. He was the first of several mentors who passed this message on to me.

Quite a few years later, Del McCoury told me that after the New York show Monroe asked him to come to Nashville to play banjo with him on the Opry. Del had been working with Jack Cooke regularly, so he turned down the offer. But after a few days he had second thoughts, and he went to Tennessee to play for Bill Monroe. That same weekend, Bill Keith was in Nashville visiting with Earl Scruggs and working on a banjo book. Keith had stopped backstage at the Ryman Auditorium to play fiddle tunes with Sam and Kirk McGhee. When Monroe heard Keith play banjo, he knew he had to have him in his band. He asked Del to play guitar and sing lead—neither of which Del had any experience with. By teaching Del during his tenure, Bill was molding the future bluegrass star who was to carry the torch that Bill was to hand to him many years later. The band, with Bill Keith on banjo, Del McCoury on guitar, Bessie Lee Mauldin on bass, and various fiddlers, performed to great acclaim over the next months. I had the great fortune to hear them play at Sunset Park. The twin fiddlers for that show were two Bluegrass Boy regulars—Joe Stuart, who could play just about any instrument with strings on it, and Benny Williams, who regularly played guitar for Grandpa Jones.

This was music overload for me. At Sunset Park the first-row benches are about two feet from the front of the stage, and sitting on the bench puts the performers' knees at about eye level. I could see and hear everything that happened. The power of Monroe's performance, along with Del singing duets, was intense, and the twin fiddles were like nothing I'd ever heard. Improvisation in harmony? Impossible!!

I had upgraded my imitation Stradivarius copy to a Heberlein violin, and I had asked my grandfather, who had been a master carpenter and stair builder, to make a case for me. He put together an oak box with dovetail joints and made a tracing of my fiddle to create the inside of the case. It was definitely

made to stand the test of time, weighing over ten pounds with nothing inside it. By this time I had formed a band called the New York Ramblers with David Grisman and the banjoist Winnie Winston. We had stars in our eyes. David got me really turned on to other Monroe fiddlers, especially the twin fiddle team of Vassar Clements and Bobby Hicks. I loved the blues in Vassar's playing and the swing in Hicks's. I had never played music with anyone like Grisman; he was always coming up with ideas for tunes. And as he would show me and Winnie a new tune that he wanted the band to do, the music kept changing, ever evolving, until one of us said, "Enough, already!" Every time David picked up the mandolin, new sounds would pour out of his fingers. We recorded sixteen tracks in a studio at Columbia University that year, and three of the cuts were Grisman originals: "New York Ramble," "Cedar Hill," and "Fanny Hill."

The New York Ramblers, following in the footsteps of the Greenbriar Boys, went to Union Grove, North Carolina, in the spring of 1964 to try our luck in the annual World Championship instrumental and band old-time and bluegrass competition. We were nervy, brash, and confident as we went through the various stages of the competition. At the end of the weekend we took several instrumental ribbons and won the overall band competition. When we returned to New York City we were treated like conquering heroes of the folk scene (5, 6, 7). We were booked into a two-week stint at Gerde's Folk City (in September), and Ralph Rinzler helped us to get a performance spot at the Newport Folk Festival that summer (8). We played again at Gerde's in the spring of 1965, just before I left for Nashville.

Also in the spring of 1965, the Kentucky Colonels, which featured Roland White on mandolin and the legendary Clarence White on guitar, played for two weeks at Gerde's. The Colonels were a four-piece band, but occasionally Scotty Stoneman or Bobby Sloane joined them on fiddle. Neither made the trip from California to play at Gerde's, so when I saw that they were missing a fiddler, I hung around them and tried to be as conspicuous as possible. Roland asked me to play a few tunes with them on one show, and after that I tried my hardest to join them every time I could. Playing next to Clarence White, a guitarist who played fiddle tunes better on the guitar than just about any fiddler I'd ever heard, was truly inspiring.

While I attended Rutgers University I took elementary courses in music to learn about theory, chords, and to read notation better. That training became a lifesaver while I lived in Nashville and worked as a Bluegrass Boy. Usually, songwriters would cut demo sessions of their tunes to be marketed to the various

recording artists in and around Nashville. For copyright purposes, the music had to be notated. I was often called by the studios and publishing houses in Nashville to pick up a demo recording and write out a "lead sheet" (standard sheet music for most pop songs—a melody line in music notation with the lyrics underneath the notes and guitar chords above) from it. After the first semester of music at Rutgers, the head of the music department invited me to join a special composition class that was to be taught by a freelance musician from New York City who, besides being a composer and arranger, played cello in the lucrative business of recording sound tracks for television and radio commercials. After hearing my story, he suggested that I notate all the fiddle stuff—the licks, the tunes, the bowings—because the musicians in New York were always being asked to try to sound like authentic fiddlers and never quite made it work. After I put it down as best I could, he looked it over and suggested I take it to a publisher. I sent the manuscript to *Sing Out!* magazine and left it for consideration. As time went by and I got no response, I forgot about it. But years later the project was picked up again, and the result was *Bluegrass Fiddle*, my first book and the first of its kind.

After the New York Ramblers' success at Union Grove, Ralph Rinzler took more notice of me. Bill Monroe was booked to play some one-night college-circuit shows in the Northeast in the autumn of 1964, but he didn't want to pay to bring musicians from Nashville for one-night gigs, so Rinzler suggested that Monroe use Bill Keith on banjo (after leaving the Blue Grass Boys, Keith had moved back to Boston), Peter Rowan on guitar and as lead singer, and Tex Logan (the New Jersey math genius from Bell Labs) on fiddle. As luck would have it, Tex could play only one of the dates, at Jordan Hall on October 31, 1964, so Ralph asked me to play the October 9, 1964, date at Barre, Vermont, and a date next spring at Dartmouth College. Rinzler paired us up to play twin fiddles at Jordan Hall. I knew this was my chance. I forgot about my schoolwork and spent hours every day with every Monroe recording I could get my hands on. Tex and I rehearsed a couple of times to work out melody and harmony parts, and he showed me licks that Bill liked to hear (9).

At the Dartmouth gig, as we were warming up, Peter Rowan told me that Monroe had asked him to return to Nashville to work with him. I was jealous and determined to get the same invitation. I became intensely focused as we went on stage, and for the two shows I played the hottest, most driving, and most swinging fiddle I could summon up. And the audience responded. It didn't hurt that Monroe had introduced me as a college boy from New York

City. I was one of their own, playing with the Father of Bluegrass. After the shows Monroe asked me to come to Nashville, too. I told him I was in my last semester of college and that if he was serious about having me, after I finished I'd come down. He said that was fine, that he'd be glad to have me. I struggled through the rest of the semester, telling anyone who would listen that I was going to Nashville to play fiddle for Bill Monroe. Most people, including my parents, smiled and responded indulgently, "Sure. Fine." While it might have been possible for a northern / city / college-type kid to play bass, guitar, or banjo in the big leagues with Monroe, grasping the genre well enough to play fiddle was too much of a stretch for anyone to imagine. Anyone but me, that is. And this tenacious attitude came to the fore again, later in my story.

As patronizingly indulgent as my parents were with my playing bluegrass while I was in college (they came only once to a performance that I was in, and then only because it was in Carnegie Hall in 1963 with the Down State Rebels), my father continued to have fantasies about me attending law school after college. He never directly tried to dissuade me from going to Nashville. I think he knew that to do so would only steel my determination. I know he was sorely disappointed when I went. My mother, however, was happy to see me pursue a dream. But she would never dare say a word of encouragement and contradict my father's position. After I left the Monroe band and returned to the nest, one of the first conversations I had with him was about what I planned to do now that my fling was over. Unfortunately for him, my plans did not include law school, and my fling had just begun.

CHAPTER 3

Nashville, 1965–66

During my last two years of college, the New York Ramblers played whatever shows we could find. David Grisman was starting to blossom as an inventive writer of mandolin tunes, and the New York Ramblers spent time in the recording studio making what we hoped would be a marketable album. David produced a 45 rpm single with one of his instrumentals, "Cedar Hill," on one side and a vocal sung by Jim Field, "The Old Old House"— a song we had heard that Bill Monroe had just recorded—on the other side. David created a label, Silverbelle, and distributed the single to radio programs that played bluegrass music. We were all thrilled when David got calls from musicians in the Washington, D.C., area to tell him that they had heard the band on the radio.

In the spring of 1965 we were booked to play a few shows in the New York area as the opening band for Jim and Jesse McReynolds and the Virginia Boys. I'd always liked their music and especially appreciated the playing of their longtime fiddler, Jimmy Buchanan, so I was disappointed to find that he wasn't with the band when we played those gigs. The McReynolds Brothers modeled their band on the format that Monroe had laid down—mandolin, banjo, and fiddle as lead instruments (they did, however, flirt at times with other marginal

bluegrass instruments)—but their choice of material was very different. They had a sweet, fluid vocal style that was reminiscent of the Blue Sky Boys, the Delmore Brothers, and the Louvins, and they were always testing the limits of the bluegrass sound. Jesse McReynolds created a unique virtuosic style of cross-picking the mandolin that involved playing split strings and sounded like the banjo rolls of Scruggs-style banjo picking. In their early years they had a few different fiddlers, including Vassar Clements, and banjo players such as Bobby Thompson and Allen Shelton. They recorded at times with electric instruments and the Dobro guitar (an instrument Monroe particularly disliked). And they were adventurous enough to record an album of Chuck Berry songs and an album dedicated to the Louvin Brothers.

So I had an idea. On Sunday, May 30, 1965, Jim and Jesse McReynolds and the Virginia Boys were scheduled to perform at Sunset Park (10). I had just taken the last final exam of my senior year at Rutgers University a little more than a week earlier, and I immediately began packing. I was hoping to meet the McReynolds Brothers at Sunset Park and hitch a ride on their tour bus back to Nashville. If that didn't work out, I was ready to hit the road and thumb a ride to Music City, USA. As it turned out, they were happy to have me aboard. Jesse told me that they were heading to Virginia after the Sunset Park shows to play a one-nighter, and then on to Nashville. I put my gear on their bus, and after their last show I was on my way, giddy with anticipation. They cleared off an extra bunk for me, but I was so intoxicated with the atmosphere of the bus that there was no way I would get any sleep that first night. I had a wonderful time talking with Allen Shelton and the McReynolds brothers.

We got to Nashville early Wednesday morning, June 2, and they dropped me off on the corner of Broadway and Fourth Street, just down the block from the Ryman Auditorium. I called Peter Rowan to tell him I'd made it to town and to ask if he knew a place I could stay until I got settled in. On Friday, June 4, Peter brought me to the Ryman Auditorium so I could meet with Bill Monroe. It was quite an experience to be behind the scenes for the first time. The Opry shows on stage at the Ryman could best be described as an exercise in controlled chaos. Backstage was more uncontrolled. The Ryman Auditorium was originally designed as an evangelical church. The backstage area was definitely not configured to accommodate thirty or forty country music stars, their bands, costumes, instruments and cases, and electronic gear. There were two rehearsal rooms on one side of the stage, each about the size of a large broom closet, and on the other side of the stage . . . nothing.

I said hello to Monroe, as if to say, "Well, you told me to come down and play fiddle for you. Here I am." He looked a little surprised to see me. I had assumed that the job and Monroe were waiting for me, and my talks with Ralph Rinzler did nothing to dissuade me of that notion (in all fairness, Ralph hadn't encouraged me, either). Bill and I chatted for a little while, and he told me to bring my fiddle the next night, Saturday, June 5, and said, "If you have a hat, wear it." After that conversation, I hung around backstage, somewhat awed by the whole scene. The Friday- and Saturday-night Opry shows were always packed to capacity. A late show on Saturdays was added to accommodate the overflow crowd, and the schedule was never the same both shows. On each side of the stage area a schedule was posted indicating who was to play on which fifteen-minute segment. Performers were expected to be in the wings ready to go on when announced. Since there was sometimes a gap of several hours between a performer's appearances on the early and late shows, the artist was free to go and do whatever. It made for some tense, interesting interludes backstage. That first night at the Ryman I made myself as inconspicuous as possible and just drank it all in.

The next evening, to the amusement of the Nashville natives I encountered, I took a bus from where I was staying, near West End Avenue, down Broadway wearing a cowboy hat and carrying my fiddle. I got off at Fourth Street, and as I walked towards the Opry, I saw a line of folks stretching around the block waiting to get into the Ryman Auditorium. As I walked past them and into the alleyway that led to the backstage door, cute girls were looking at me trying to figure out if I was some big-name country player they might soon see on stage. I remember thinking that I could get used to this really fast.

I went to Monroe's dressing room, which also accommodated the Osborne Brothers, Wilma Lee and Stoney Cooper, and Sonny James. Bill ran through a couple of songs with me, and the "Watermelon on a Vine" intro he always used, then he asked me what fiddle tunes I'd like to play. I wanted to be safe that night, so I told him "Bill Cheatum" and "Panhandle Country." We were rehearsed and had to make room for the other bands to change, so I went to the hallway outside the dressing room and saw, next to the restroom, Lester Flatt and Earl Scruggs and their band, warming up between the fire extinguisher and the stage door. I was amazed that they didn't rate dressing-room space, but I knew nothing at that time of the rancor between them and Monroe.

Just before we went on stage, while standing in the wings with Bill, Peter Rowan, James Monroe (Bill's son and bass player), and Don Lineberger (the

banjo player), I remember thinking that I had "arrived"—this was it, my dream come true. We went on stage; I played the theme and launched right into the vocal number. There was a commercial break, and another performer played. When Bill announced the members of the band to the audience and to the WSM radio listeners, he said, "And over on my right is a young fiddler who's trying out for my band. His name is Gene Lowinger. He's a Jewish boy from New York City, and if you folks really like the way he plays, I'll give him the job." Then he looked over at me and just waited for me to start playing "Bill Cheatum." I was dumbstruck; I thought I already had the job. I wanted to crawl beneath the floorboards. My left-hand fingers were shaking, and I had trouble getting the bow onto the strings—it felt just like my first night playing with Roger Sprung at Gerde's Folk City. It was the custom for the emcee to call for applause when a musician began an instrumental. Thank God for that: no one could hear the bow bouncing on the strings. But I settled into it, and by the time I was through the first chorus, I had regained control. The banjo picked up the tune, and I looked over at Bill. I think he could see the fear in my eyes, and he smiled and winked just before I came in with my second chorus. I coasted from then on. It wasn't unusual for people in the audience to walk up to the stage to take photographs of the stars, or to hand them a program for an autograph. While I was playing, I looked down and saw a group of fans gathered at the front of the stage just staring up at me, like they'd never seen anyone from New York before. The audience responded warmly when I was done, and we left the stage. Being a man of few words, Bill didn't say anything to me between shows, nor just before we went on the second time. We opened the set with "Panhandle Country," and after another star sang a tune, Bill did his rendition of "Muleskinner Blues." After the second show, while we were packing up in the dressing room, Bill told me to be at the bus by 2:00 AM, that we had to be in North Carolina later that day. I had made it. I was a Bluegrass Boy.

After that road trip I opened a checking account, paid up my membership in the Musician's Union local, and began looking for a more permanent place to stay. The first thing that came to mind was to go to the Jewish Community Center to see if any families might have a room to rent out. When I told the receptionist that I was from New Jersey, she mentioned that one of their youth group leaders, a graduate student at Vanderbuilt University, was also from New Jersey (as if we were from the same state up north we should know each other!) and mentioned his name. It turned out that not only did I

know him, we had belonged to the same youth group in high school. I called him, and we became roommates.

I was twenty-two, and although I'd lived away from home while attending college, that was a short bus ride back. This was the furthest away I'd ever been, and for the longest time, in a new city and unfamiliar culture, with no friends or relatives. In the mid 1960s, although the country music industry brought a substantial amount of affluence into Nashville, the general population did not warmly embrace the culture. Whenever I introduced myself as a Bluegrass Boy, the general reaction was, "Oh. . . ." I called home many times, and called David Grisman to complain about how tough Monroe was to work for. I was hoping that David would say something to his buddy Ralph Rinzler, who was still booking shows for Monroe, and he'd tell Bill to go easy on me. A few times, between road trips and Opry shows, I got a flight home for a few days. My dad was always happy to pay for them, hoping that I'd not go back. But I always did.

When Bill first took me on as a fiddler, he made it clear that he expected me to work hard and learn quickly. Especially work hard. Bill never asked from anyone what he wasn't ready to do himself. He set the mark for us and challenged us to match him, on stage and off. I quickly got the feeling that as the fiddler in the Blue Grass Boys I was in a special position, a tiny bit exalted, but a great deal more was expected of me. As hard as Bill worked on his farm, he expected me to work on the fiddle. During the long stretches of downtime in Nashville, I had a lot of time on my hands. I practiced for hours every day to learn licks and bowings that Bill had shown me or told me to "get with." He wasn't verbally expressive, but he showed me on the mandolin what he wanted on the fiddle. I thought I knew how to play the fiddle when I went to work for him, but the lessons were just beginning.

The fiddle I was using didn't have a lot of power in its sound, and Bill didn't like it. I got a call towards the end of the next week from Bessie Lee, Bill's companion, to say that Bill wanted to meet me at the Opry early that Friday night. He had brought two fiddles along with him; one had a red varnish, and one was almost black. He told me to take them home and pick whichever I wanted to use. I chose the black fiddle and used it for my tenure as a Bluegrass Boy. Many years later, when I had a chance to talk with other fiddlers who had worked for Monroe, they told me that that fiddle—Bill called it "Blackie"—was his favorite.

There were many times on the road when he'd tell me to get my fiddle (usually at about one o'clock in the morning) and sit across from him. He'd

play something on the mandolin and wait for me to play it back. If it wasn't what he wanted, he'd play it again. And again, and again, until I got it right. He couldn't, or didn't, tell me in words what was wrong with what I was doing, and many times I thought I'd gotten it. I'd turn to Peter Rowan, who was driving the bus, and say, "Didn't I just play that?" And Peter would say, "Nope." So I'd try again. Bill's timing was impeccable. When he double stroked a note, he could put the accent on either the down- or upstroke with the pick, and it made a big difference in the flow of the melody. Once he got so frustrated with me he grabbed the fiddle from me to show me how to move the bow. That's when I realized that he couldn't play a lick on the fiddle. I chuckled, as if to say, "See? It isn't so easy!" The other band members who were sitting nearby became stone still, afraid of what Bill's reaction might be to my seemingly arrogant attitude. The more time I worked with Bill, the sassier I became. He teased me mercilessly, and I gave it right back to him. The others in the band sometimes cringed at what I got away with saying to him. But I was his fiddler. He drove me hard, but he cut me slack none of the others got.

Playing fiddle in his band meant that I had to start most of the songs. So I had to know just about every song he ever recorded, and what key they were in. I stood close to Bill on stage, and often during applause I could hear him testing his voice. He had the next song in mind and wanted to see in which key he could reach the high notes. Then, while he was introducing the song to the audience, he'd chop a chord on the mandolin to show me the key. Some tunes never changed, like "Footprints in the Snow"—always in E; or "Mule Skinner Blues"—always in G. But songs like Jimmy Rogers's "Blue Yodel No. 4" might be in B-flat, B, or C, and "In the Pines" might be in E or F. So I had to be able to play effective intros in a number of different keys. I had started to figure out the technique while with the New York Ramblers, but I perfected it with Bill. I would just put my first finger on the tonic of the key and use it almost as a guitar or banjo player would use a capo. When Bill talked to the audience, I stood just to his right, so I could see what the chord was and know the key. The others didn't have it so easy, especially Peter Rowan, who stood to Bill's left and couldn't see the mandolin fingerboard, only the back of Bill's hand on the neck. He depended on me at times to tell him the key. Sometimes I did, sometimes I didn't. And sometimes, when I thought he was being particularly condescending to me, I told him the wrong key.

When I first started as a Bluegrass Boy, the banjo player was Don Lineberger. He didn't sing in the band, so I filled in with the baritone part of the trios and

quartets. It was difficult because I took many fiddle solos and played a lot of backup. To get in close around the microphone, I had to put the fiddle and bow down so I wouldn't poke someone in the eye. These were the golden days of performing when all we had was one or two microphones in the center of the stage, and we had to group around it to sing and dance around each other to move in and out for instrumental solos. And there were no sound checks. In later years, when I was taking photos of Bill, I recall sound engineers coming backstage to ask Bill to do a sound check, to which he responded that he didn't need one. The banjo player Dana Cupp would grab the soundman on his way out and tell him to just do the best he could.

Singing trios and quartets in close like that gave us a smooth sound because we could really hear and match each other's vocal tone and articulation. Bill could blend his voice with many different singers, but with some his voice and the ensemble sound was really special. He had that special sound with Lester Flatt, Mac Wiseman, Jimmy Martin, Del McCoury, and Peter Rowan. It was a treat to sing trios with Bill and Peter. Sometimes Bill's tenor harmony over the lead melody line didn't quite follow standard voicing. So as the baritone singer, I had to vocally jump around, and Bill wasn't always pleased with my efforts. He'd pull me aside after a set and play the baritone harmony part he wanted me to sing on the mandolin and then expect me to get it right the next time we sang that song—which could be the next night, the next week, or the next month.

Early on, when I began working for him, Bill was asked to be filmed for a syndicated WSM Grand Ole Opry show that was sent to various affiliate stations throughout the South. I remembered doing the filming (this was quite a few years before videotape) but didn't remember the songs we performed. Years later, when I saw a movie made by Rachel Liebling, *High Lonesome: The Story of Bluegrass,* I saw a small clip of Monroe that showed the Blue Grass Boys singing a the chorus of "Uncle Pen," and the fiddler was singing in trio. At that time I hadn't remembered singing in the band, but I noticed that the banjo player was left-handed (he played the banjo upside down), and I knew that the only one to ever do that with Monroe was Don Lineberger. I sat up and looked hard, and . . . surprise, surprise. There I was. That clip was used by WSM in 2000 as part of a PBS series called *A Century of Country Music.* When WSM called to ask me to sign a release and told me I'd be compensated one hundred dollars, I told them I didn't care about the money (they sent it to me anyway), but I wanted a copy of that tape. I got it, and I treasure it. Not long

after that taping, Don Lineberger resigned from the band and was replaced by Lamar Grier. The first time we rehearsed, Bill asked Lamar if he could sing baritone, and when he said yes, Bill turned to me and said, "Just play the fiddle."

Backstage at the Grand Ole Opry, when it was at the Ryman Auditorium, was a constant unfolding story. There were sideman musicians who hung around and waited for a lead performer to ask them to play on the star's segment of the show along with his or her regulars. Someone in the control booth knew every one of them, kept track of who played what with whom, and submitted the payroll to the musician's union every week. The sidemen were all talented musicians who could play in any style that was needed by the headliner. One of them, the fiddler Buddy Spicher, played regularly with Monroe. Bill always invited him to play twin fiddles with me. I marveled at how Buddy could hear me play a solo once and the next time through play a two-part harmony with me. As much as Bill loved the sound of a fiddle, two fiddles were heaven for him. Many times while warming up, Buddy and I would jam with tunes like "Scotland," "Roanoke," "Cheyenne," "Panhandle Country," and "Wheel Hoss," and if a tune wasn't originally a twin fiddle piece, Buddy would make it into one as naturally as if it were always meant to be.

In the dressing room adjacent to ours, some of the other old-timers hung out. Roy Acuff would sit with Sam and Kirk McGhee and talk about their livestock and crops. One evening when Sam saw me, he asked me to get my fiddle to play some tunes. They had some friends with them from the neighboring farm, and as I walked back into his room I overheard him tell his buddy, "Now you listen to this Jewish kid play the fiddle!" When I first met Roy Acuff at the Opry, he invited me between shows to the back room of Tootsie's Bar, which was directly across the alleyway from the Opry stage door. It was a private room for Opry players to hang out in, and the drinks flowed freely. Roy asked me to join him in what I later learned was a rite of passage. When I got there, out came Roy's jug that he'd brought from his farm. It was at least 150 proof white lightning. That was my only experience with Roy's chemistry experiments; it was enough to last a lifetime.

Many musicians passed through Bill Monroe's bands over the years. Sonny Osborne had been his banjo player in the early 1950s (when Sonny was fourteen years old), and Jimmy Martin (11) often stopped backstage to see Bill and beg for his old job back as the lead singer and guitarist for the Blue Grass Boys. Jimmy recorded intense, high-powered duets with Bill that typified the "high lonesome" sound ("Memories of You," "When the Golden Leaves Begin to

Fall," "Memories of Mother and Dad," "Little Girl and the Dreadful Snake"), vocal trios ("On and On"), and gospel quartets ("River of Death," "Walking in Jerusalem Just Like John," "A Voice from on High," "He Will Set Your Fields on Fire"). Sometimes Jimmy would show up a little bent from moonshine and want to sing a duet with Monroe, but Bill had little patience with inebriated people and put Jimmy off. Jimmy Martin would stand outside the dressing room door and talk loudly to anyone who would listen about how Monroe was keeping him off the Grand Ole Opry. Bill would tell us that Jimmy Martin was the only person who kept Jimmy Martin off the Opry, and he'd call Martin "a sorry excuse for a man."

But there were times when the camaraderie between Monroe alumni blossomed into impromptu jams. One night, while Sonny Osborne (12) was playing "Pike County Breakdown" with Bill (a banjo tune he recorded with Monroe), his brother Bobby Osborne (13) wanted to get into the fun, so he asked Bill to sing a duet with him. Monroe asked which part Bobby wanted to sing, and he answered, "tenor." Then Bobby asked Bill what key the tune was in, and Monroe picked a key two steps higher than that in which he usually sang it. It was fun watching Bobby Osborne turn red trying to hit notes that would have been just right for a female singer. One night between shows, when Bill had laid his famous Lloyd Loar Gibson F5 mandolin in its case, I surreptitiously watched Bobby pick it up to play a few notes. That mandolin had a unique, penetrating sound that was powered by the extremely high action of the strings. It took a man with a powerful grip to play an A chord cleanly. Bobby plunked a few notes, looked around, and quietly laid the instrument back in its case.

When we returned to Nashville after a road trip in late October, I was feeling more than my usual discomfort at dealing with life in the unwelcoming environment of town. I made one of those quick hops back to New Jersey for some home cooking. My father, understanding how lonely I was feeling, had spoken with our community rabbi, who asked me to stop by to speak with him. He mentioned the spiritual leader of a synagogue in Nashville and suggested I call him when I returned to Tennessee. I did, and the rabbi asked me to come by one evening at the synagogue. He was warm and friendly and let me know he was always available should I need to reach out. He suggested that I come to a service some Friday evening or Saturday morning when I was in town. The synagogue was on West End Avenue, a short distance from where I was living. I let Bill know that I might be late for the first early Opry show the next Friday evening. Bill said it was okay with him. That prompted Bill to talk

with me about Jewish music. He said he knew the music used a lot of minor sounds and that since it was such old music it must be full of "ancient tones." That was a phrase Bill was fond of using.

It was usual for the Blue Grass Boys to get a call from Bessie when Bill got bookings for shows, and I got a call directly from Bill only once in my tenure with him. He wanted to join me at a service at the synagogue. We went together, and it was a strange feeling sitting in an environment in which I had been raised with a man who had never experienced it before. I glanced at Bill several times. He had his eyes closed, his chin raised, and he looked as though he was just absorbing the atmosphere around him. At the end of the service, Bill and I greeted the rabbi and shook hands. Bill thanked him for the music and said, "I really liked the songs, and I'm gonna find a way to use some of those notes in my music." Many years later, when I had come down to Nashville to photograph Bill, and we were traveling on his bus to a show (as was his custom, it was about one o'clock in the morning), he told me to get a fiddle. I said, "Bill, I don't play anymore. I'm not a fiddler. I'm just here to take pictures." He answered, "I want to show you this tune I wrote. You'd like it. It's got a lot of Jewish notes in it." And he showed me how to play "Lonesome Moonlight Waltz." No matter how many years had gone by, I was a Bluegrass Boy fiddler, and Bill Monroe was my teacher.

Bill Monroe was fifty-three years old when I started playing fiddle for him. That was just about the same age as my parents. It was hard not to think of him as "the old man." Looking back, it doesn't seem so old. Bill was hardened to life on the road. We often traveled not on his tour bus—which we dubbed "The Bluegrass Special" and other, less generous members of the band named "The Bluegrass Breakdown"—but in a station wagon loaded with all the instruments and our personal effects. He was not quite as generous with us as he was to become in later years. We never stayed in motel rooms; Bill did, and he left us to fend for ourselves.

On our second or third road trip together, Bill wanted me to take my turn driving the bus, which I felt sorely indisposed to do. Since I was the newest member of the band, mine was to be the "graveyard" shift, in the wee hours of the morning. The bunks were double-decker and open-sided. Bill, however, had a small room in the back of the bus, directly over the diesel engine. I never understood how he could sleep with the noise of the engine and smell of diesel fuel. What happened was not intentional, but I couldn't have planned better if I'd tried. We came to a spot on the highway with an S curve, and I was still

learning how to gauge the tolerance of the "power" steering on that dinosaur. As I took one arc of the curve I oversteered, and the bus listed heavily to one side. As we approached the opposite arc of the curve, I oversteered in the other direction with the same results. The band members who were sleeping in the upper berths rolled out into the aisle, first from the left side, and then the right. There was some "muted" mumbling, and Bill emerged from his cocoon, hair and clothes disheveled, and said to Peter, "You drive." Then he turned to me and said, "You ride shotgun." My career as a bus driver was over.

I was always a little edgy when I sat up with Peter as he drove with "saucer" eyes. We often had strange conversations that I couldn't quite follow, nor do I think could Peter. I always suspected that his mind was somewhere other than on the road. As punishment for my poor bus-driving skills, Bill made me the Blue Grass Boys' navigator. I was responsible for picking the route for our longer trips, and if we got lost, it was always my fault. If we pulled into an unfamiliar town at 3:00 AM, I would be awakened and told to find out how to get to where we needed to be. I grumbled about it to Bill, but I really didn't mind. Anything was better than having to handle that behemoth.

The bus had many miles on it before Bill owned it, and it had chronic mechanical problems. The air compressor, which provided pressure for the air brakes, constantly malfunctioned. The escape valve, which released excess pressure when the air tank was full, froze up every couple of hundred miles. The driver had to stop, and I had to open the back end of the bus and bang on the valve with pliers or a wrench to release the excess air. If we forgot to do it, well . . . there were some dicey moments on the road.

I was excited to learn early in June 1965 that the Blue Grass Boys were booked at Sunset Park, where I cut my teeth on hardcore bluegrass. I knew many of the regular patrons, as well as the members of the house band and the owner of the park. And it was close enough to New York that my former bandmates and perhaps my family could come see me perform with the Father of Bluegrass Music. I called David Grisman to tell him to spread the word, and I told my parents in the hopes that they would come and meet Bill. I eagerly looked forward to the road trip. It was early Sunday morning when we pulled into the park. As the patrons arrived we were just roaming around in our road clothes. I talked casually with quite a few folks I knew and hadn't seen since the previous summer, and spent about a half hour chatting with Olabelle Reed, one of the singers of the house band, the New River Boys and Girl. They just assumed I was there to see the show. Then I got back on the bus to change into my

suit and cowboy hat. When I got off the bus carrying my fiddle and went to the warmup room, Olabelle's mouth fell open. There I was, one of those city kids who regularly made the summer weekend trip from the New York area to Sunset Park just to play and hear some authentic bluegrass music, as Bill Monroe's fiddler! It was a special time for me, and the people in the audience whom I had sat next to for so many shows loved seeing me perform with Bill. I had started out as one of them (kind of) a few years before, and there I was on stage with a star of the Grand Ole Opry. It was a transforming experience for me and for the audience.

But my family never made it. Many years later I had a heart-to-heart chat with my mom about my musical life, and she brought up the story of what happened. They were taking a car trip for several days with my aunt and uncle through the Pennsylvania Dutch country around Lancaster and had planned to spend the day with me at Sunset Park. My father was driving on back roads through the countryside, and when it seemed to my mother that they were getting no closer to West Grove and the park, she asked my father to stop and get directions. He ignored her and just kept driving with no apparent direction in mind. She was furious for days. I was deeply saddened when she told me this story. She was always a supporter of whatever creative adventure I tried, but my father wanted nothing but for me to fulfill his expectations. She was afraid to stand up to him that time. But further along on the road of my musical adventures she put up more of a fight in support of me. It still saddens me today that because of my father's stubbornness, they missed out seeing me blossom in the first independent adventure of my life's journey in music.

We played many small parks and one-night gigs that summer, sometimes playing the Opry on Friday and Saturday night and heading out after the last show to play somewhere on Sunday. Bill had often asked Peter, Lamar, and me to put together some songs we could do as the Blue Grass Boys, without him. I wanted no part of it, so whenever time was available to work out some material I disappeared into the back of the bus, behind Bill's bunk room, to practice some solos. I was hot to learn some Benny Martin licks and had been listening intently to his solos on the Flatt and Scruggs recording of "Dear Old Dixie." At this point, Bill was not on speaking terms with either Lester or Earl. When they passed each other in the backstage hallway of the Ryman they would turn their backs to each other. There was a great deal of speculation as to why, but nobody knew for sure. The solos that Benny Martin recorded had unique and distinctive licks in them and couldn't be mistaken for any other tune or fid-

dler's style. I relished the thought that Bill could hear me while I was playing them in the back of the bus. One day on stage, Bill asked for requests from the audience, and someone persistently hollered for the banjo tune "Dear Old Dixie." We all cringed; it was, after all, a tune that Earl Scruggs had recorded and made popular. Bill turned to Lamar and asked him, "Do we know that tune?" Lamar looked over at me, and I smiled. He said to Bill, "I do." When Lamar played it, Bill didn't take a solo. I took two: both of the Benny Martin choruses note for note, and after each solo the audience applauded.

We ate at whatever diners or truck stops presented themselves along the way, and the diet was strictly deep southern fried. Bill seemed to function just fine that way, but it was hell for me, and I was vocal about it. Bill started in teasing me mercilessly about stopping somewhere so I could get my pablum. I just sat still and stewed; nourishing my anger and letting it fester was something for which I had good training at home. One day we were on our way to a show, and Bill took sick with food poisoning after eating in a grease pit. By the time we got to the show he was almost completely incapacitated. He wanted us to go on without him and was really annoyed that we had no material worked out that would give him a break. Trooper that he was, he went on. We did the show as usual, but I never heard about pablum after that.

There were times when we would get to a show that had been poorly advertised or was poorly attended because of inclement weather. Sometimes there were as few as ten people in the audience. Bill was devoted to his fans and would insist that we do the show. He came from the same stock as the audience, laboring farmers, and he would tell us, "Those people work hard for their money, and if they's gonna spend it on a ticket to see me perform, then I'm gonna give 'em their money's worth."

We performed at three major festivals that summer. The first was the New York Folk Festival in June 1965, not long after I joined the band. The second was the Newport Folk Festival on July 24. The third was a historic groundbreaking event running from September 3 through 5, Labor Day weekend, at the Roanoke Bluegrass Festival on Cantrell's farm in Fincastle, Virginia. It was conceived, produced, emceed, and entirely overseen by the onetime Bill Monroe manager Carlton Haney. That was the first ever multiday bluegrass festival, the precursor to the extravaganzas that are staged all over the country and the world.

The New York Folk Festival was spread over several days, and each performance had a theme. "Grassroots to Bluegrass to Nashville" included Johnny Cash, June Carter, Doc Watson, Bill Monroe, the Greenbriar Boys, Grandpa

Jones, the Blue Sky Boys, the Statler Brothers, and Jimmy Driftwood. It was quite a lineup and a bit of a risk for the promoters to put on in Carnegie Hall. Some of the names were familiar to the New York folkies, but it was not a big draw, and the hall was far from full. To advertise the event, the promoters arranged for a procession of performers up Fifth Avenue from Forty-fifth Street to Fifty-seventh Street, the heart of upper-class and affluent middle-class shopping in New York. We rode with Monroe in a straw-filled, horse-drawn wagon and played bluegrass tunes. To most of the shoppers on Fifth Avenue it was just another day, with another ho-hum event. New Yorkers constantly experienced bizarre happenings and unusual people around them; they have became blasé about such events.

We had been playing in the Washington, D.C., area in early July when the Bluegrass Breakdown lived up to its name. Bill rented a station wagon for the drive back to Nashville, but he had a problem getting us to Newport for the festival. With no bus, we each had to buy our own tickets to fly there (Bill later compensated us for the fare). I looked forward to playing at Newport in front of thousands of the "folkies" who were of the same generation and culture as me. And there I was on stage before them, playing with Bill. It was quite a scene getting on stage and seeing the mass of people out in front of us. By that point in my tenure as a Bluegrass Boy, I felt at home on stage. Bill taught me that I belonged with him in front of all those people. I realized early on that Bill would be right behind me chopping away chords on that powerhouse mandolin when I was at the microphone, and that it would be pretty difficult to stumble. Tex Logan was at the festival to play with the Lilly Brothers, so Bill asked him to play twin fiddles with me. When we came out and ripped into "Watermelon on a Vine," I was charged up, and the feeling spread into the crowd. We jumped right into "Panhandle Country," and after the applause died down, Bill introduced the Blue Grass Boys. When he got to me, just as he had many times before, he said, "And over on the right-hand side of the stage, on the little fiddle, is a young man from New York [I really wasn't from New York, but it sounded much more effective than saying I was from New Jersey]. He's the only Jewish bluegrass cowboy in the country. His name is Gene Lowinger. Let's give him a big hand." I had never taken offense at Bill's introduction. I knew that he was proud that, coming from a background that was so unfamiliar to him, I had loved his music so much that I'd worked hard to learn it, and I played an instrument in the style of his beloved Uncle Pen. There was applause, but there was also a palpable tension in the air. Bill knew

he'd said *something* to cause it. So he asked me up to the microphone to ame-liorate the situation. He chatted with me for a few seconds and asked me to "say something in Jewish to the audience." I froze. The audience froze. Then I had moment of transcendent clarity, and I knew what to say: "Oy vay." That was it. There were chuckles from those that understood, and those that didn't, couldn't. I went back to my place next to Tex, and the show went on. After the show I told Bill that I understood that he had meant no harm but that some might take it the wrong way, so I would appreciate if he didn't introduce me that way anymore. He said, "Okay." That was the last I heard of it.

At that show Bill performed his standard tunes. Tex and I traded solos on "Muleskinner Blues," and it was high-octane stuff. We did "Blue Moon of Kentucky" with twin fiddles. Bill was so excited that he was whooping and hollering in the background. That performance at Newport was one of the first times Bill and Peter performed "Walls of Time." The song was a work in progress over several road trips. Bill and Peter would sit across from each other and talk about the poetry of the lines, how the phrasing should be sung, the chord progression, when to get soft or loud. And I sat there and watched the whole thing take shape. At that performance, Tex and I played twin fiddles on it. It was later released on two different Vanguard CDs, which featured blue-grass performers at Newport from various years. "Walls of Time" appears on one CD featuring Bill and Peter doing the song as a duet at a music workshop and a second CD with the entire band on the main stage.

After the Saturday performance, Bill's son James and I took a Greyhound bus to Washington, D.C., to retrieve the repaired bus. Bill insisted that I go because he thought I would know the roads in and around New York and would be able to help James navigate. We got back to Newport late on Sunday, packed up our things, and started the long drive back to Nashville. James continued to drive, and I rode shotgun. I dozed off while traveling through Connecticut, and when I woke up we were somewhere on Long Island, way off course. We just hoped that we could get back through New York City and onto the New Jersey Turnpike before Big Mon woke up. He might not have known much about New York City, but he certainly knew that it didn't take ten hours to get from Newport, Rhode Island, to Newark Airport.

The most historically significant shows I played as a Bluegrass Boy were at the Roanoke Bluegrass Festival. None of us in the band had a clue what would happen, but there was a modest turnout (by today's standards) for all the shows. The setting was, to phrase it kindly, rustic. Security was maintained by Carl-

ton Haney roaming the grounds with an honest-to-God, real-life six-shooter wrapped around his waist in a cowboy holster. Never could tell what kind of problems would arise with all those hippie types (which included the likes of Sam Bush and David Grisman) attending. Besides the Blue Grass Boys, there were Jimmy Martin and the Sunny Mountain Boys, the Stanley Brothers and the Clinch Mountain Boys, Don Reno, Red Smiley (they were no longer playing together), and individual performers such as Doc Watson, Clyde Moody, Mac Wiseman (14), and Benny Martin. Few of us had any idea of the influence on the musical culture that festival would have. At one point, Carlton saw to it that some film was shot, scraps of which have shown up on the Internet. Photos, a few to follow here, were taken by some spectators. But whatever there is, considering the impact of the event on the future of bluegrass, it's not enough. This enterprise paved the way for other promoters to give a shot at multi-day, multi-band events. It spawned festivals such as Merlefest, the Winterhawk (now Greyfox) Festival, and a host of others.

Bill played some of his standard shows at Roanoke. Don Lineberger had left the band by that time, and had been was replaced by Lamar Grier. I had become a tried and tested, pumped-up Bluegrass Boy, full of swagger. The centerpiece of the festival was a semistaged show for which Carlton Haney had written a script, "The Story of Bluegrass," which he reenacted at later festivals also. His idea was to trace the development of Bill's music from its beginnings by reuniting Bill with performers who had worked with him to perform songs that they originally recorded together. For a good portion of the show I stayed on stage to play fiddle while Bill sang "Six White Horses" with Clyde Moody, "Little Girl and the Dreadful Snake" with Jimmy Martin (whose banjo player at the time was Larry Richardson), and "When the Golden Leaves Begin to Fall" with Carter and Ralph Stanley (although Ralph never did play in Bill's band).

When Benny Martin was on stage with Bill, they had a conversation about bluegrass fiddling—how it was a unique combination of old-time, swing, and blues, and that there were lots of popular violinists over the years, like Venuti and Rubinoff, but whatever they did couldn't compare to the drive that bluegrass fiddlers had. I knew of quite a few bluegrass fiddlers, and I had heard of Venuti, Grappelli, Eddie South, and Stuff Smith. But I'd never heard the name Rubinoff before. Honestly, I thought Bill had either made it up or misstated a name of some classical musician he'd heard about. Years later I discovered that there was, in fact, a Russian classical violinist named David Rubinoff who emigrated to the United States Faced with stiff competition from the likes of Jascha

Heifetz, Nathan Milstein, Mischa Elman, and others, he decided to perform a more pop-oriented style. Rubinoff toured with Eddie Cantor for a while and then had his own traveling show. Bill, with his insatiable appetite for different sounds to bring into his creation, had heard Rubinoff perform gypsylike and pop renditions of songs, and that sound had stayed with him over many years.

The pictures taken at the first Roanoke Bluegrass Festival are all classics. A photographer asked us to stand together for him, and while we were posing, another person off to the side took a picture of us. That photo was sent to Bill with copies for each of the Blue Grass Boys (15). Bill liked it so much he used it for a promotional shot long after the personnel in the band changed. The shots of Monroe on stage at Roanoke (16, 17, 18) were originally color slides shot by the Washington, D.C., bluegrass bassist Tom Gray. I ran into Tom many years later at a bluegrass event, and he told me that he had these pictures, but since they were slides he didn't think they could be made into prints. I asked him to send them to me, and I had prints made from them. When this project started to come together, I contacted him, and he told me he'd had them digitized. These photos represent a significant moment in bluegrass history, as does the photo taken in Tom's basement at a picking party, also originally a color snapshot (19). Tom reminded me of the story about that party: it was already in progress when, at about 1:00 AM, his doorbell rang, and there was Bill Monroe. We had played earlier that night in Gettysburg, Pennsylvania, and we were on our way to the Washington, D.C., area. We played until the sun came up that morning, a common occurrence for Big Mon once he got wound up.

In the autumn months Monroe's schedule slowed considerably. There were long stretches when the only shows we played were the Grand Ole Opry on Fridays and Saturdays. Bill encouraged me to expand my musical horizons, and he asked Buddy Spicher to work with me. I met with Buddy a few times to work out twin fiddle parts, but he was too busy as a recording-session sideman to give me much time. I contacted the concertmaster of the Nashville Symphony and began taking violin lessons from him. My lack of experience reading music was a definite handicap, and my predisposition to playing eighth notes with some swing hindered my study of the Bach E major violin concerto. But the challenge the music presented was a new glimmer of light in the far distance. Once again I saw something to reach for, and I began to itch for it. The Blue Grass Boys were booked on a three-week trip to the West Coast during late December. I packed my scale book, violin exercises, and the music for the Bach concerto, determined to do better when we got back to Nashville.

The first stop was at a college in Portland, Oregon, then on to San Francisco, and two weeks in Los Angeles. When we had layovers, Bill got a motel room for himself and left us on the bus. We were booked to play the Ash Grove in Los Angeles for the week after Christmas, but there was nothing to do for the week before. I had two sets of relatives (that I had never met) in the Los Angeles area at the time, so I got in touch with them, and they invited me to stay with them. Bill took strong exception to this, thinking that I should stay with the rest of the band rather than abandon them and run off to stay with cousins I'd never met. By this time into the trip—and my tenure as a Bluegrass Boy—my patience with being on the road was being sorely tested, and the glory of being a Monroe fiddler was beginning to wear thin. During the few days I stayed with my cousins I had time to practice scales and the Bach concerto for a few hours a day, and I was really getting a charge from it.

My cousin had invited some friends over for dinner one evening, one of whom was a violinist for a movie studio orchestra. I listened to his stories about working as a freelance musician in Los Angeles and about putting sound tracks to movies, and I was once again bitten. Over the next few days I took some long walks, turning things over in my mind. Could I really see myself playing bluegrass much longer, in an environment in which I felt isolated and alien? And I asked myself a question that made me chuckle whenever I put it to words: "Was this any way for a nice Jewish boy from New York to live?" Up until that time, my answer had been a resounding yes. But on that road trip it changed. Playing bluegrass fiddle was not without its challenges, but I was beginning to feel that there was something lacking, certainly not in the music, but in my expectations for myself. I was becoming disenchanted, but couldn't put my finger on exactly why. During the week layoff before the Ash Grove gig, I decided that I was going to give Bill my notice once we were headed back to Nashville. I was going to return to the New York area to study classical violin in earnest. I didn't talk with anyone about the decision; I didn't investigate the possibilities of actually doing it, or what the future might hold for me. I just saw the direction I wanted to go and decided to go full speed ahead. Once I had made the decision, I felt lightheaded and almost giddy with excitement.

The Ash Grove date came, and I stayed with cousins who lived within walking distance of the club. Just before we played there, the Blue Grass Boys were invited for Christmas dinner with the White family—Clarence and Roland of the Kentucky Colonels. We had a wonderful time with them. After dinner we played music until the sun came up on Christmas day.

I felt entirely different that night playing with Bill. A tremendous weight had been lifted. Nothing he could say, no matter how critical of my playing he was, would make any difference. I played better, hotter, and bluesier than I ever had before. Every show at the Ash Grove crackled with energy as each of us set new challenges for the others. Every solo and every instrumental was greeted with applause. That particular iteration of the Blue Grass Boys had never played better. We were all surprised by it. Playing tours was far from a glamorous lifestyle: the same songs night after night, almost always in the same keys, in the same order, with rarely any variation, then back on the bus to drive all night and day to the next show where the pattern repeated—it can become quite tedious. But we had to get up for every show. Every time I played "Uncle Pen" or "Footprints in the Snow," it had to sound fresh and exciting. We had to put personal animosity and/or feelings aside for that forty-five minutes and be the Blue Grass Boys—not always easy to do. So when those moments of inspiration come to a performer, they are clutched at and cherished. Those times on stage at the Ash Grove became spiritually transforming, and the buzz lasted long after we left the audience behind. If it happened one of every twenty performances it was exciting. For it to extend for a whole week was special indeed.

I learned many years later that every time I pick up my instrument, whether to practice or perform, I'm engaged in a spiritual exploration. Sometimes I'm carried into uncharted territory that results in one or a series of epiphanies that leave me awed. If it happens while I'm practicing, I have the luxury of pushing at the edges to see where it might lead; if in performance, I have the thrill of giving it to my listeners. Later in life I was to learn that this is true of any artist when he or she engages his or her muse in a creative exploration. I have a beautiful mistress that gives me back whatever I invest in her. If I am angry, the sound I get back is angry, and in the process of taming that shrew, the shrew tames me.

We climbed aboard the bus to drive across Arizona, New Mexico, and Texas, and Texas, and Texas. . . . We were scheduled to play a show in Shreveport, Louisiana, before returning to Nashville. The day we left I had called to tell my parents that I was giving my notice. That night, when everyone was asleep but me, Bill, and Peter Rowan (who was driving), I told Bill I'd be leaving in two weeks. That would include the Shreveport show and the following weekend on the Opry. Bill was not happy about it, especially after the way I had played at the Ash Grove. The turnover in Bill's band was high, and I was another casualty on a long road for him. Years later we discussed my leaving, but that's

best left for later in my story. We stopped in El Paso for a day to stretch our legs walking around town and over the bridge to Juarez, Mexico, and then we headed on to Louisiana. Once back in Nashville I set to work shutting down my life there. I closed out my bank account, which, after buying my airline ticket home, left me with two hundred dollars. That was exactly the amount with which I had opened the account a little over six months earlier, when Jesse McReynolds dropped me off in the center of Nashville.

I played the Opry that last weekend, and after the Saturday-night shows, Bill and his son James drove me to the airport for my late-night flight back home. I was touched by the way Bill said goodbye to me. He let me know that I would always be welcome to play with him and that he wanted me to stay in touch. When I got on the plane my head was swimming with thoughts of what lay before me, not what I was leaving behind. I was still very young and had not a clue as to what I had accomplished at that point in life, or how profoundly my experiences with Bill Monroe would affect the rest of my life. As I look back on it now, I can say that there is nothing I have been more proud of than to have played fiddle for and been mentored by a man who profoundly affected the course of American music. Since I left Monroe, there has never been a day when I have not been a Bluegrass Boy. As the story unfolded, I, with my nearsightedness, saw a great expanse ahead of me that would lead to new goals and away from bluegrass. I saw Bill a couple of times over the next several years at Tex Logan's annual parties at his home in New Jersey (20), and then . . . nothing. But the further I moved from that last contact with Monroe, the closer I drew to my next, twenty- five years later.

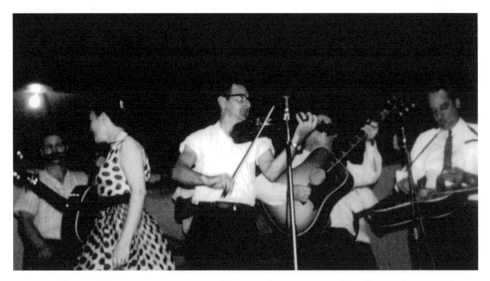

1. The New River Boys at Sunset Park, Pennsylvania, 1963. Olla Belle Reed, guitar; Ted Lundy (hidden), banjo; Sonny Miller, fiddle; Alex Campbell, guitar; and Deacon Brumfield, dobro guitar (bass player unknown).

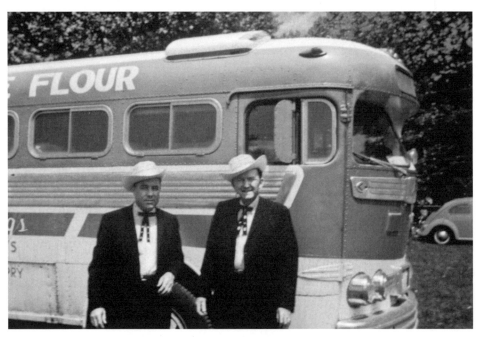

2. Lester Flatt and Earl Scruggs in front of their Martha White Flour tour bus, Sunset Park, Pennsylvania, 1963. Converted from color.

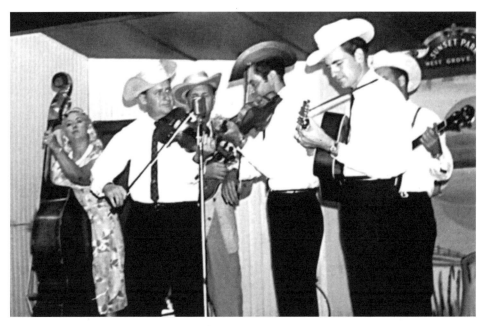

3. Bill Monroe and the Blue Grass Boys at Sunset Park, Pennsylvania, 1963. Bessie Lee Mauldin, bass; Joe Stuart, fiddle; Bill Monroe, mandolin; Benny Williams, fiddle; Del McCoury, guitar; and Bill Keith, banjo.

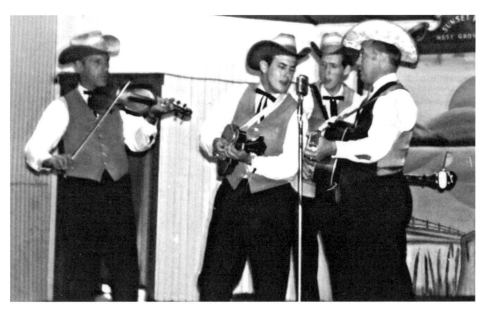

4. Jimmy Martin and the Sunny Mountain Boys at Sunset Park, Pennsylvania, 1963. "Tater" Tate, fiddle; Bill Torbert, mandolin; J. D. Crowe, banjo; Jimmy Martin, guitar; and Helen "Penny Jay" Morgan (hidden), bass.

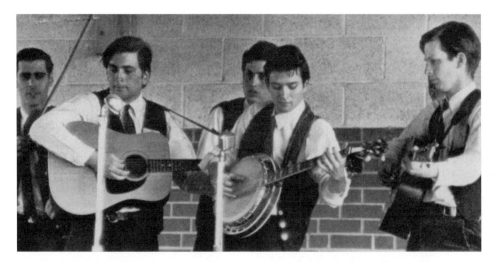

5. The New York Ramblers at Union Grove High School, North Carolina, 1964.
Gene Lowinger, fiddle; Jody Stecher, guitar; David Grisman, mandolin;
Winnie Winston, banjo; Jim Field, guitar; and Fred Weisz, bass (hidden).
Photo by Bob Yellin.

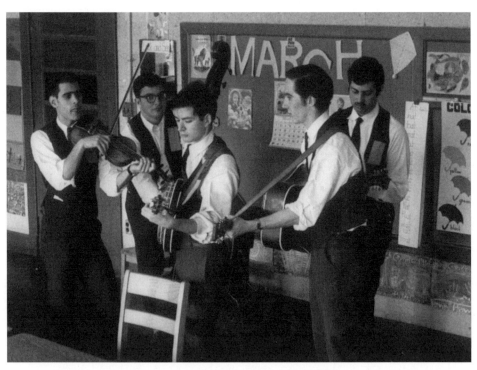

6. The New York Ramblers at Union Grove High School, North Carolina, 1965.
Gene Lowinger, fiddle; Fred Weisz, bass; Winnie Winston, banjo; Eric Thompson,
guitar; and David Grisman, mandolin. Photo by Bob Yellin.

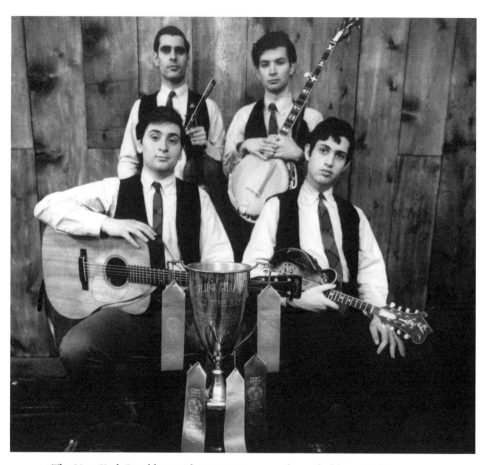

7. The New York Ramblers with Union Grove trophy and ribbons, Folklore Center, New York City. Gene Lowinger, fiddle; Winnie Winston, banjo; Jody Stecher, guitar; and David Grisman, mandolin. Used by permission, David Grisman archives.

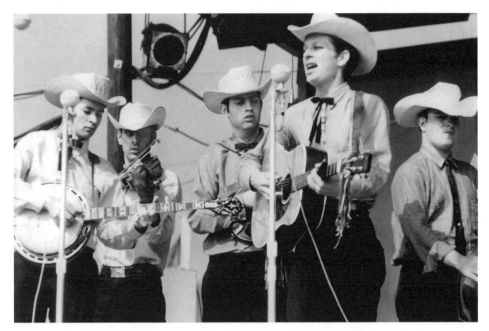

8. The New York Ramblers at the Newport Folk Festival, 1964. Winnie Winston, banjo; Gene Lowinger, fiddle; David Grisman, mandolin; Jim Field, guitar; and Fred Weisz, bass. Photographer unknown. Converted from color.

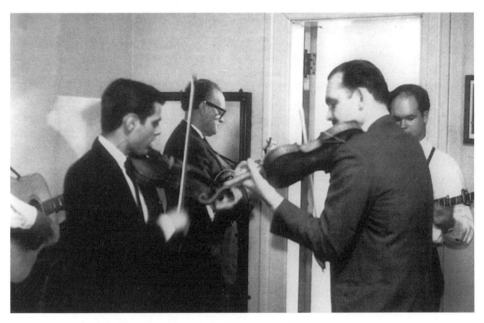

9. The Blue Grass Boys at Jordan Hall, Boston, October 31, 1964. Peter Rowan (hidden), guitar; Gene Lowinger, fiddle; Bill Monroe, mandolin; Tex Logan, fiddle; and Bill Keith, banjo. Photographer unknown.

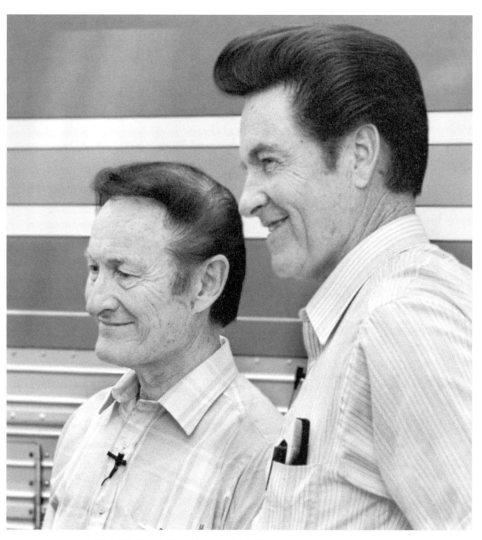

10. Jesse and Jim McReynolds at Sunset Park, Pennsylvania, June 7, 1992.

11. Jimmy Martin at Sunset
Park, Pennsylvania, May 1992.
Converted from color.

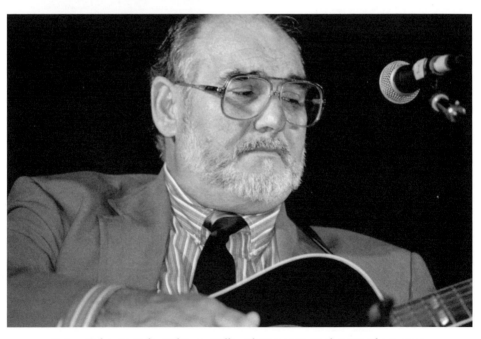

12. Sonny Osborne at the Delaware Valley Bluegrass Festival, September 5, 1992.

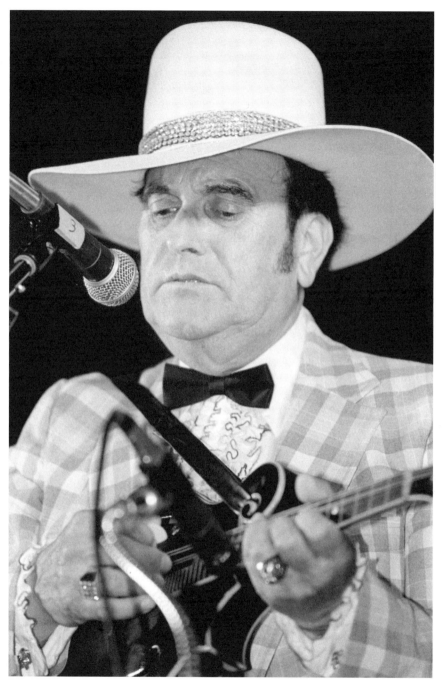

13. Bobby Osborne at the Delaware Valley Bluegrass Festival, September 5, 1992.

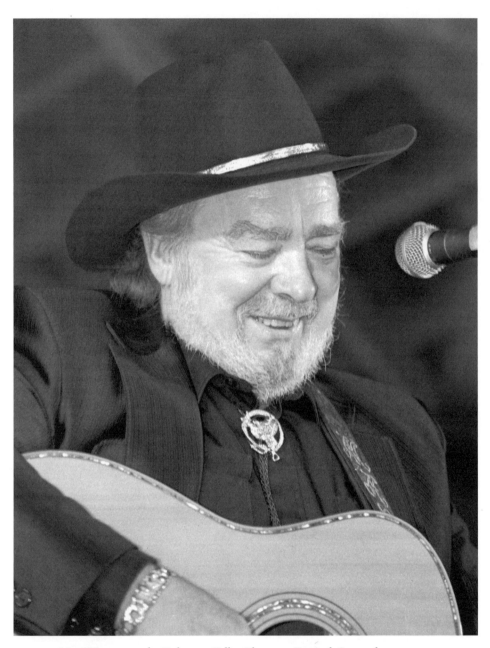

14. Mac Wiseman at the Delaware Valley Bluegrass Festival, September 5, 1992.

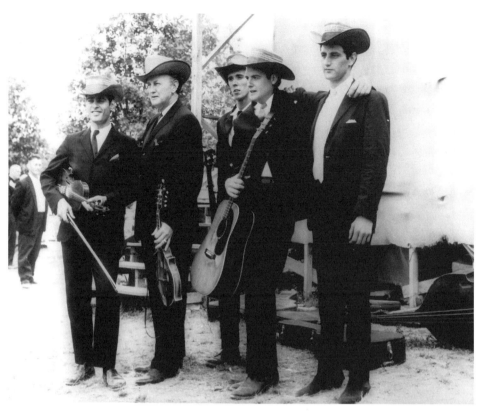

15. Bill Monroe and the Blue Grass Boys in Fincastle, Virginia, September 3, 1965. Gene Lowinger, fiddle; Bill Monroe, mandolin; Lamar Grier, banjo; Peter Rowan, guitar;. and James Monroe, bass. Photographer unknown.

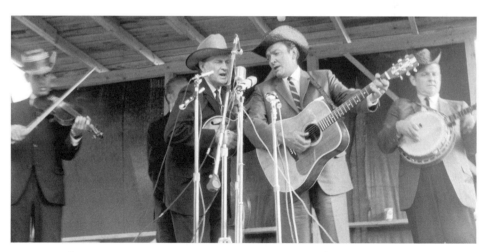

16. Bill Monroe on stage at the Roanoke Bluegrass Festival during the presentation of Carlton Haney's *Story of Bluegrass.* Gene Lowinger, fiddle; George Shuffler (hidden), bass; Bill Monroe, mandolin; Carter Stanley, guitar; and Ralph Stanley. © Tom Gray, used by permission, all rights reserved. Converted from color.

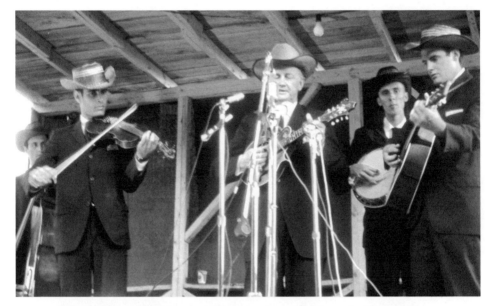

17. Bill Monroe and the Blue Grass Boys on stage at the Roanoke Bluegrass Festival. James Monroe (hidden), bass; Gene Lowinger, fiddle; Bill Monroe, mandolin; Lamar Grier, banjo; and Peter Rowan, guitar. © Tom Gray, used by permission, all rights reserved. Converted from color.

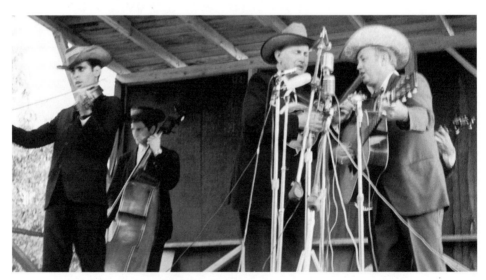

18. Bill Monroe and the Blue Grass Boys on stage at the Roanoke Bluegrass Festival. Gene Lowinger, fiddle; James Monroe, bass; Bill Monroe, mandolin; Jimmy Martin, guitar; and Larry Richardson (hidden), banjo. © Tom Gray, used by permission, all rights reserved. Converted from color.

19. Party in Tom Gray's basement. Jack Tottle; Tracy Schwarz, fiddle; Gene Lowinger, fiddle; and Bill Monroe, mandolin. © Tom Gray, used by permission, all rights reserved. Converted from color.

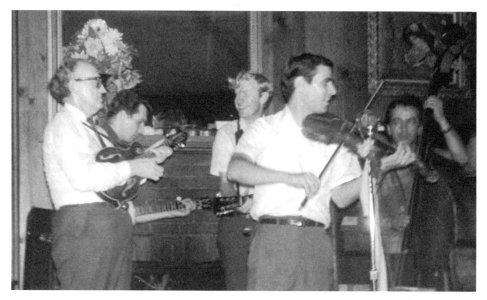

20. Party at Tex Logan's house celebrating Bill Monroe's birthday, 1968. Bill Monroe, mandolin; Vic Jordan, banjo; Jim Rooney, guitar; Gene Lowinger, fiddle; and Roland White, bass. Photographer unknown. Converted from color.

CHAPTER 4

Home to Study Violin, 1966–92

I had made a firm decision while playing at the Ash Grove in Los Angeles. I was as determined to follow through with it as when I decided to play fiddle for Monroe. If there was one thing I learned from Bill, it was to have a vision and stay true to it. I was twenty-three years old, and I wanted to become a classically trained violinist. "It will never happen," I was told. "It has never been done and can't be done. People start studying when they are six or seven years old, even younger, to develop the techniques required for the demands placed upon violinists." Okay, I thought, so I might fail, but I'm going to try. After a few days at home, my father asked me about my plans. I told him I wanted to go back to school, and he smiled—I'm sure he thought I meant law school. When I told him I wanted to go to music school, his face went blank— nothing, no reaction. I became really annoyed and even more determined to follow through with my plans. Not having a firm foundation in music theory was definitely a hindrance, but I had a good ear and a good memory, and I could use those to overcome obstacles.

I called my college music teacher and asked him to recommend a violin teacher in New York. He told me I was crazy, blah, blah, blah . . . and asked me to come into New York for lunch. I met him as he was coming from a record-

ing session in midtown Manhattan. He was with several other string players from the session, and as he introduced me, he grinned, as if to say, "Boy, you don't know what you're getting yourself into." That afternoon he told me what life was like for a string player in the New York freelance music industry: he had to run around to play two or three, sometimes four sessions a day; he had to suck up to contractors who hired musicians for those sessions, for the Broadway shows, and the orchestras that played for the several ballet and opera companies in the metropolitan area. He told me about the back stabbing and personality assassinations. He told me I'd have to spend at least four years, probably more, practicing four or five hours a day for the privilege of begging to audition for a job that paid an unlivable wage. It all seemed so terribly exciting to me. I saw him and his associates doing it. They lived every day with their instrument in their hands. How bad could that be? He assured me that if any of them could see a way to make as good a living doing anything else, they would. So what happened to all that poverty he was trying to convince me I would be living in? He said maybe one of every hundred get as far as he did. Over several hours he told me all this, and I kept asking him for the name of someone with whom I could study.

He relented, asked around among his acquaintances, and came up with several people who would be willing to try to work with me. The first two were violinists who, along with him, ran from one session to another. Neither were teachers, neither had a clue as to how I thought or worked, and neither had any time to devote to teaching. Then he sent me to a specialist who worked with talented children: pay dirt. I got a part-time job for four hours a day, went into New York twice a week for lessons, and practiced scales, technical exercises, and musical pieces four hours a day. I connected with a local community orchestra and rehearsed with them one night a week. Coming from playing a style of music that required an entirely different type of discipline, it was difficult to adjust to playing in a large group of musicians who were all reading the notes they were supposed to play from an orchestral part. I had practiced long, hard hours to learn to play bluegrass, but I made up the sounds in my head, and I didn't have a roadmap of directions to follow. To grab hold of the idea of playing the exact notes that were written on the page, with the exact bowing that was worked out for the whole violin section, was probably the most difficult obstacle in those early days.

I had trouble wrapping my mind around the character and style of the various pieces of music my teacher threw at me. This was much more subtle

and complex than playing a fiddle tune or twelve-bar blues. I had to develop a completely new vocabulary of musical expression, and it all had to be readily accessible to execute. One piece in particular, "Beau Soir" by Claude Debussy, was particularly elusive; the sound of impressionist music seemed discordant to my novice ears. So my teacher suggested that I spend some time in front of Claude Monet's *Water Lilies* at the Museum of Modern Art. That seemed strange, because until that point in my development music was definite, concrete, and absolute, rooted in the sound I heard in my head and in my ability to translate that into what my bow and fingers could pull from the instrument. But I stopped into the museum after my lesson that day, and when I walked into the room with those huge panels, I was mesmerized.

That was an epiphany for me, my first exposure to art as a stimulus for my emotions, and I knew right away why she had sent me to see those paintings. I sat there for over an hour that day, and over the next few months I returned many times. I was learning to catalog my feelings so I could call them up and inject them into the music I was trying to create on the violin. That was the first time I'd ever made an intuitive connection between my visual and aural experiences. Both types of perception were to dominate the rest of my life. As I began to delve further into the arts, I began to see how form and structure could combine with emotional content to transmit powerful messages to an observer or listener. That's what made for riveting performances: the magical combination of talented musicians performing works of composers who had mastered the art of concretizing ideas into sound and words. Although I didn't realize it at the time, that was what in 1963 snared me that first time I ever saw Bill Monroe.

Over the years, as I developed my performance skills and juggled the worlds of bluegrass and classical music, I often had to flip a switch inside to become either fiddler or violinist. The differences in the overall approach to performing made it difficult to apply the techniques of one to the other. The language the musicians used to talk about what they did was so different that I came to realize that it was nearly impossible to talk about one world with those in the other—the classical people thought of themselves as being far above the baseness and banality of hillbilly music, and the bluegrass people scoffed at the rigidity and intellectual snobbery of classical music. Over time I understood that there were limitations to both styles and that to find fault with one over the other for not achieving what it never set out to do in the first place was an exercise in futility. After years of bouncing back and forth, I began to see

that the one achieves ascendancy over the other in its flexibility and ability to absorb and integrate new ideas and sounds.

After taking lessons for a few months, I told my teacher that I wanted to audition for music conservatories. She told me it couldn't be done. Hmm . . . I'd heard that before. But she worked with me anyway. I spent hours every day practicing scales. I listened for hours to great violinists playing the classical repertoire. I lived, ate, and breathed violin music. For the auditions I was required to play part of a violin concerto, so in collaboration with my teacher we chose the Mozart Violin Concerto No. 3 in G major. I spent weeks on the beginning of it, but progress was painfully slow. The audition was fast approaching, and I wasn't ready, so my teacher tried to dissuade me. She didn't know what being a Bluegrass Boy was about. I felt that point on the head of Monroe's mandolin sticking me in my back, prodding me on. Since my biggest obstacle was reading the notes, I had to find a way to do without them. I stopped in a record shop (as in LP: long-playing, 33 rpm) and got a recording of the concerto. How different could it be from learning "Sally Goodin" from Tommy Jackson? It wasn't. I played that recording by David Oistrakh a hundred times. I sang along with it, played air violin along with it, and then I slowed it down to 16 rpm and picked it apart note by note, measure by measure.

By the next lesson, one week later, I was ready. My teacher looked at me skeptically as I took out my violin and asked me how I had done with the Mozart. I gave her the piano music, put the violin part on the stand, and opened to the first page. I asked her to play the introduction, which she did. While she was playing, I closed the music. I wanted her to *know* that I was doing it from memory (the notes wouldn't have done me any good, anyway—I still couldn't read them), and I played most of the first movement for her. When she asked me how I did it, I explained to her about how I had worked with the recording. Then she told me to hope and pray that I wasn't asked to sight read something at the auditions.

That spring I tried out for four conservatories, and I was asked to sight read at all four. I couldn't. I told my story to each of the audition boards, and every one had the same reaction. I was twenty-three? I had been studying less than a year? I wanted to go to a music conservatory? Impossible!! Play some bluegrass for us. So I played "Stony Lonesome" and "Mule Skinner Blues." I was nervy, but I was accepted at three of the four schools. My father's heart sank, dreams of law school gone (but not forgotten, as Bill might say).

I worked hard that whole summer practicing to get ready for school. That first year was difficult, but a joy for me. Because I already had a Bachelor of Arts

degree from Rutgers University, there was no need to deal with undergraduate academic courses, so I was free to exclusively pursue my music studies and to earn an artist's diploma. The course of study would still take four years to complete, because there was a progressive path of development that needed to be followed—music theory, music dictation, ear training, and music history. I found the studying to be simple compared to the pressures I had to deal with as an undergraduate at a liberal arts college.

The real work was in my private study of the instrument. As I had been warned, I was up against students who had been playing since childhood. I was in deep—at least up to my shoulders. I was miles behind, and I became discouraged often. My choice of schools—Mannes College of Music—was heavily influenced by the presence of one particular instructor on the violin faculty, Raphael Bronstein, and when I registered I asked specifically to study with him. The dean of the school informed me that Professor Bronstein was a world-famous pedagog and only accepted advanced students, so I was assigned to a teacher who had been on the admissions jury when I auditioned. He was the most vociferous member of that august group who told me that what I wanted to do was impossible. I took what I could get but planned and schemed to get what I wanted.

During that first year in music school I befriended a student who was studying with Professor Bronstein, and in the spring of that year I asked my friend to take me with him to a lesson. I listened to how Bronstein taught, the language he used to express his ideas, and knew in my heart that this was the man for me to work with. After the lesson was finished, he asked me if I wanted to play for him, which I did. I played the Mozart concerto with which I had auditioned for school. It wasn't very good, and he turned to my friend and asked, "Is this a joke?" My heart began to sink. My friend excused himself and left me alone with the professor. I told him my whole story—about Monroe, about learning the Mozart piece by ear, and about how I was determined to become a violinist. He didn't say "impossible!" but smiled and said, "Let's see what you can do." He gave me a lesson, during which time the next student came in and sat in an adjoining room. Professor Bronstein put me through my paces on the Mozart. He told me what to do, and I did it. He explained some concepts to me, and it all seemed so natural—his ideas about visual intonation and about "spaces" and how to move the bow. He turned to the next student and said somewhat facetiously, "He's a genius." Then we joked a bit while he mulled over what to do with me. Finally, he said that if I studied with his daughter,

Ariana Bronne, for the summer, and did well with her, he would take me as a student the next semester, that I should tell the dean of the school he had accepted me. I went to the dean the next day, told him that I wanted to study with Professor Bronstein (later I began to affectionately call him Prof), and the dean reminded me that the professor accepted only very advanced students. I told him I'd already played for Prof, and that he wanted to work with me. Cocky? Arrogant? Maybe a little, but these people needed to know what being a Bluegrass Boy was all about.

I worked with Ariana for two months that summer. I came into New York for a lesson a week and worked on the driest, most boring mechanical exercises along with the Bach violin concerto in A minor, and in the fall I was ready. That was the beginning of a relationship with the Bronstein family that was to grow into something really special in my life. Here were my next mentors. Prof was everything I had expected of him and more. I was inspired to practice four hours a day. Monroe had showed me the rewards of hard work, and I was determined for the same results with Prof. I worked diligently for him and again during the next summer with his daughter. The following summer I traveled with them to a summer music camp in Blue Hill, Maine, to play chamber music and continued to work with them for a number of years during the school semesters and at summer music institutes. In 1970 I received my artist diploma for the violin, and then went on to graduate school for a master of music degree in performance.

The most significant qualification of an instrumental-performance major is to perform, and a graduation recital is mandatory. Prof worked with me to put together a recital program of sonatas and short pieces that he felt I could present effectively. The first half of the program consisted of Handel and Beethoven violin sonatas. The second half was a collection of short pieces— the first was my choice: Debussy's "Beau Soir," followed by "Roumanian Folk Dances" by Bela Bartok and "Suite Populaire Espagnol" by Manuel De Falla (a collection of Spanish dances and folk tunes). I missed the point of these last two completely until the day of the recital, while I was doing a run-through in the school's recital hall. Some of my classmates sat in to listen and complimented me on how relaxed I seemed playing that music, but then, of course, I would be relaxed—it was *folk music!* I had a wonderful time that evening at the recital. And when I took my bows afterwards, my friends shouted for me to play a fiddle tune. So I dragged up "Bill Cheatum." After the program, some friends gathered in the reception room, and I was pleased to see that my

father and mother were there. Prof reassured my father that I would do fine as a violinist, while the rest of us enjoyed champagne.

Prof conceptualized many principles of playing that most students previously learned by rote repetition. The old method depended upon chance and the natural gifts of the player. Much of the music played by traditional American performers was created this same way. A fiddler would have heard tunes in the environment in which he grew and developed and learned to play them by repetition over many years. That's what I was up against by trying to learn to play bluegrass when I was twenty years old. I did things to accelerate the process of learning without understanding what I was doing or why it sped the process along. But, as the results bore out, it worked. When I started to study with Prof, the tools he taught me were the same I had used to learn fiddle. But within the structure of his schooling they became concrete. He always emphasized *slow practice.* My number-one rule when I teach my students, whether classical or traditional, has always been, *If you can't play it slow, you can't play it fast.* I wish I had a dollar for every time a student floundered in a lesson and told me they could play something better if it was faster. Their playing may have seemed better, but only because the mistakes didn't last as long at the faster tempo. Prof's whole approach to practicing was to maximize the effects of a minimum amount of practice. Slow practice was essential. When I heard him talk, his teaching fit me like a well-worn glove.

Monroe talked endlessly to us about setting the notes in right. At first that seemed a little nebulous to me, but over time I came to understand what he was looking for. I didn't learn to put what he was talking about into words until Prof talked to me about the same things—time and space. Music is an art that requires time to unfold, as does drama or dance, and the fiddle is a very spatial instrument—bow space creates sound over a period of time, so the two are intertwined. Monroe may not have put it quite like that, but it's what he meant.

In the spring of 1971 I got a call from an editor at Oak Publications in New York City. I was preparing for student juries—an ordeal by fire that performance students are subjected to every year to prepare them for the big, bad real world—and I was focused on my practicing. The editor asked, "Are you still interested in having your book published?" My book? I wrote a book? She said, "The book you submitted to *Sing Out!* magazine in 1965." Apparently, after I wrote out all those licks and fiddle tunes at the suggestion of my music teacher at Rutgers, I had submitted the work for consideration. I had totally

forgotten about it, but what the hell? I dimly remembered that it was already written, so why not? I said, "Sure, I'd like that." And I set to work with the publisher. If I had known how much effort is involved in preparing any work for publication, I would have had second thoughts. The process is tedious and demanding, and those who make a career in the publishing industry have earned my unflagging admiration.

When I told Prof about the project, he loved the idea so much that he asked me to work with him on a treatise on violin pedagogy. He was a brilliant man, well-educated and erudite, but Russian to the core, and his working knowledge of the English language was limited. I saw this as an incredible learning opportunity and a wonderful endorsement of me as a pupil. I spent many hours with him working on the text, the music for the major violin concertos, and the Bach unaccompanied violin sonatas. The work was to stretch over a period of a few years. During the school year I would have my lesson with him, have a bite to eat, and then set to work reviewing what I had already written, before moving on to new material. Prof would go over the printed notes with me, measure by measure, and detail his interpretation or technical comments. Then he'd pick up his fiddle and play the passage so I'd understand completely. Working this way was like having in-depth, concentrated lessons on every work in the violin repertoire. I took my notes home and translated them into coherent English (sometimes calling Prof to clarify a point), and the next time we got together, I would read what I had written for his approval. During the summer we did the same at the beach. I loved the man, and I loved the work.

Bluegrass Fiddle was the first book of its kind to codify bluegrass fiddle technique; there was no language or style already developed to work from. I was pleased with what I accomplished with that book, but nothing could compare to the feelings I had working on the Prof's treatise. That was a work for the ages: a synopsis of the Russian school of playing that had given rise to many of the greatest violinists of the twentieth century—Jascha Heifetz, Nathan Milstein, David Oistrakh, Leonid Kogan. As I worked with him and listened to him talk about music and the techniques of playing the instrument, I felt as though I'd heard it all before. The overall message was the same as Monroe's: the dignity and soul of the music is more important than the performer; there is spirituality in any worthwhile music, and it is the performer's job to find it and bring it to his or her audience. At the time I was working with Prof, I was too young to understand or verbalize it, but deep inside I saw the connection, and it was a joy for me to be immersed in the work.

An integral part of the process of becoming a complete musician was ensemble training—playing in orchestras and chamber-music groups. During the summers when I was studying with Prof, I traveled with him and Ariana to chamber-music camps, where they coached students in ensemble playing. During the school year, the pressures of studying academics and preparing lesson material and the demands of the world in general kept us all busy with little or no time to indulge in what for most string players is "party time," the big chocolate cake with rich creamy icing: string quartets. The summer months were a time to forget it all—except our own practicing—and enjoy interacting and making beautiful music with other students. Small ensemble playing—trios, quartets, quintets, and such—gave me the opportunity to put into practice all the music and violin skills I worked so hard to acquire during the year.

The discipline and principles of music were applied the same way in ensembles as to our own individual playing, but it was more difficult with an ensemble because everyone in the group had to be focused exactly the same way, to create the same sound with the same bowing, and the playing had to be seamless. This was very different than playing with the Blue Grass Boys, where Bill set us up against each other to get us to rise to the occasion and shine like stars. The first time I was exposed to this philosophy of group playing, a new world of music opened to me. The quartet—or any ensemble, for that matter—had to play as one: four people playing one instrument with sixteen strings to make one sound. Chamber music, and especially string quartet playing, became the most gratifying type of music for me to play and has remained so after many years. The first summer of music camp, Prof scheduled me to play second violin in a group that was to prepare the Ravel string quartet. Since I had yet to understand the personnel dynamics of ensemble playing, I was miffed that I wasn't playing first violin . . . in *some* kind of group. Truth be told, I wasn't yet advanced enough to do that. Prof explained to me that the job of the second violinist in a quartet, while not so glamorous as the first violinist, was more important to producing a unified ensemble sound and that I should be flattered that he thought enough of me to give me such responsibility for an advanced piece of music. In other words, "Be quiet, and do what you're told." It was a gentle admonition to remind me that this was not the Blue Grass Boys, and I was not the star of the show . . . yet.

As I grew closer to Prof and his family during my student years, the time I spent with him, especially during the summers, became more intense and meaningful. We would often go out for dinner and then settle back and listen

to recordings of the great masters of the past, most of whom Prof had seen perform many times, and some of whom he knew personally. It was a treat to listen to him talk about the performances of Fritz Kreisler, Joseph Szigeti, Jascha Heifetz, and many others, as well as ensembles such as the incomparable Budapest Quartet. I became steeped in a cultural bath of Russian thinking and began to explore more of that philosophy of life. I read authors such as Dostoyevsky, Gogol, and Chekhov and listened extensively to Russian composers and performers. Over time, Prof's approach became an intuitive process, and often, when he stopped me during a lesson or coaching session, I knew before he said a word what the message was. This was the realization of a dream for me.

I've used Prof's approach in my own teaching with great success. And after years of experience, I see things in students when they first come to me that I'm sure he recognized in me. While we may all be created equal, we are not all the same. Some are better-looking than others, some have a natural instinct for creating affluence, and some are physically stronger and better athletes. Prof never quantified it in this way, but over years of teaching I have come to understand that there are four factors that contribute to making a good violinist (success, however, is another matter altogether). They are, in no order of importance: intelligence, physical ability, natural talent, and desire. To be a good player, a high degree of all four are necessary. I've seen players make it with only three, but not less. Intelligence is necessary because in learning to play this most difficult of all instruments, problem-solving skills are essential. Physical ability is also essential: finger coordination and dexterity, muscle control, left-right hand coordination, eye-hand coordination—it's no different than being a finely tuned athlete (in fact, Jascha Heifetz, the greatest violinist of all time, was a fine tennis and ping-pong player). Natural talent, an intuitive ability to understand the beauty and spirit of music and the creative artistry to be able to communicate that quality through sound to the listener, is also vital, as is desire: a burning need to play the instrument. Many players who are willing to make whatever sacrifice is necessary become fine violinists, while those who aren't fall by the wayside. I've had students and parents of students talk to me about making a decision between playing the violin and something else—pre-med, pre-law, whatever. I tell them, "Do it. Go for the other." If there's a choice, then there is no choice; the singlemindedness of purpose that must be present to accomplish mastery of the instrument is lacking. Once I codified these parameters, I looked back at my own career in music, and everything made sense.

I studied for my master of music degree in performance at the Manhattan School of Music in New York City. The learning environment was very different from Mannes College, where the culture was small and nurturing. At the Manhattan School competition was stiff between players who were all of a high caliber. It was a good way to train for the fierce competition for playing opportunities in every aspect of the music industry. After a year as a violin major at the Manhattan School, I studied what is considered by many violinists to be the deepest and most difficult of all solo violin works: the Brahms violin concerto. I spent the better part of a school year working on it. And after I finished it, I switched instruments and began to play viola, the violin's larger cousin. There were far fewer violists to challenge me, and while still in school I became established as a regular freelance musician in the New York/ New Jersey area, playing as a substitute with the American Symphony and New Jersey Symphony and many pickup orchestras. During my years in music school I talked often of having come from a country-music background, and once out in the business I was sometimes called upon to play that style for TV or radio jingles.

Life for a musician is rarely easy, and even with my fierce dedication I sometimes fell into a funk because of the intensity with which I had to pursue my career. Late in the 1970s, over one Christmas season, I decided to take some time off from playing to think things through. A contractor called to ask me to play second violin for some performances of Tchaikovsky's Nutcracker Ballet at a venue near my home. I told him that I was a violist, and I hadn't played violin for a couple of years. But he persisted, and it was so conveniently located that I could walk to work, so in the end I agreed.

After a few performances there was a freak accident. A dancer came too close to the edge of the stage, missed a step, fell into the pit, and landed directly on top of me. The conductor yelled at the orchestra, "Keep playing! Keep playing!" Then, pointing at the dancer who was sitting on the floor, he said, "Get out of here!" I checked my instrument to see that it wasn't damaged and continued to play. But as events unfolded over the next few days and weeks, I had suffered physically from the impact. I began to have dizzy spells, and as time when on I had a tingling sensation in my arm, pain in my upper back, and muscle spasms. Supporting the instrument grew increasingly difficult, and slowly my career as a violist deteriorated. As a result of the accident I collected a small workmen's compensation settlement, but not nearly enough to compensate me for the years of hard work I'd invested. Some time later, after having one more in an

endless series of medical examinations, it became clear that I had a deteriorating disc in my upper back that was causing two vertebrae to pinch a nerve. I took pain killers, muscle relaxants, tranquilizers, and ultimately fell into a routine of using recreational drugs. For years after the accident, my only relief from pain and discomfort was when I was floating in water, so I began a regimen of swimming every day. That developed into a workout routine of a mile a day, six days a week, for many years, through which I continued to use drugs.

Over the years I tried a few times to play, but always with the same result—muscle spasms and pain. I was emotionally devastated. No amount of determination and dedication to the dream of how I wanted to live my life could overcome the physical trauma, so I drifted away from playing the violin/viola, angry and discontented. But I didn't give up music entirely. *Bluegrass Fiddle* had generated a surprising return in royalties, so I set to work writing a second book that was eventually published in 1980 by G. Schirmer: *Bluegrass Fiddling: Fiddlers and Styles*. While that book was in editorial preparation, I was hard at work on another for which G. Schirmer had given me a commitment, sight unseen: *Jazz Violin: Roots and Branches* (1981). The work on those books kept my head in music, and having two works published in rapid succession was gratifying. But to write I had to bury myself in the sounds of an instrument that I loved like life itself, and I was often left with a bittersweet feeling at the end of the day. This was the beginning of a long, slow descent into drug and alcohol abuse that bottomed out fourteen years later. In retrospect I see that my coming back to bluegrass and my reconnection to Bill Monroe were pivotal in my recovery and my coming to a way of life that has been more rewarding than anything I could have ever imagined—but more on that later.

After working at a few dead-end jobs, I decided it was time to be retrained. I got an interview with the placement officer of a well-established computer-training institute and discussed my possibilities. She asked about my background, and when I told her I'd been a musician for most of my adult life, I thought for sure she would tell me to forget it—with no business background, I was doomed. That was the message my father had drummed into me during all those years when I was practicing four hours a day, going to classes in New York City, and putting in my time in the trenches of the freelance music business. The interviewer said that the school's best students, the easiest to place in corporate jobs as programmers and systems analysts, were those with formal musical training. She couldn't give me a reason why, but after the intensive six-month program I understood: the discipline and logic for problem solving

were the same. I could never explain why to an analyst with no musical background, nor could I explain to a musician who knew nothing about computers. But the analysts I met in the business who had the same background as I did understood the same way. There were over a hundred applicants for the forty positions in the training class. Of the forty who began, fifteen completed the course. I was third in the class. In the last month of training, the school was already sending me out on interviews, and I was offered a position at a Wall Street bank, to begin immediately. I had to negotiate with them to allow me to finish the course and get my certificate.

I wanted so much for this to be the beginning of an easier, softer life without financial difficulties, but I had my reservations. This was the first and only straight job I had ever had in my life. The regular hours were a problem at first, but I adjusted to that. Integrating myself into a team was not as difficult as I had anticipated. It was a lot like playing in a band or orchestra, without any of the requisite artistry or talent. But I didn't *think* like these people. I couldn't relate to their regimented nine-to-five lives, going home to wife and kids, and spending weekends doing ordinary things. When they'd come to work on Monday and talk about the band they heard in a club, or the concert they had gone to, I felt a knife twisting in the pit of my stomach. I stuck with the job for ten years, and it gave me a sincere appreciation for the price in dignity and individualism that many people have to pay to make a living.

During those years I continued my swimming regimen. I loved being in the water so much that I became a certified scuba diver, and the beauty of what I saw while diving moved me to try and capture it. I began to experiment with underwater photography. I knew nothing of photography, but I bought expensive underwater photo gear, assured that I would get the hang of it. That led me to take a course in photography, and there I found another channel for my artistic vision. I started to study darkroom techniques and worked every chance I could get in the school darkroom.

As we emerged from the darkroom to study our prints, the instructor would look at them and offer helpful tips to improve the work. One evening when I came through the revolving door into the light with a print in my tray, eager to see how the instructor was going to tear me apart yet again, he grabbed the tray out of my hands, looked at it intensely for a minute or two, then looked up at me and said, "Brother, you have arrived!" I knew what he meant. I was giddy with excitement. I wanted to hear it again, so I came back the next evening to work in the darkroom, to make another great picture—and the next night,

and the next night. He worked with me anytime I showed up. I had found my next mentor: Mario Cabrera. He was a freelance photojournalist, and he lit a fire in me again. I went to work at the bank every day with my camera bag. At lunchtime I went out to shoot. After work I'd change my clothes and go out and shoot again or go to the darkroom to work with Mario. On weekends I was consumed with photography, either shooting or working in the darkroom. This went on for three years.

I was downsized at the bank. I saw it coming and did nothing to get out of the way. By that time I had put in my ten years, was assured of a pension, and was ready to move on to my next adventure, financed for as long as I could make it last by unemployment insurance. The day I was fired I took a long walk uptown and shot some photos, and I went to school to tell Mario. He smiled at me, shook my hand, and said, "Great, now let's get to work." He took me out with him during the days on his photo assignments and encouraged me when I needed a push. He got me thinking like a photojournalist and seeing like a painter. I felt the artist in me start to swell again.

In June 1992, Mario called and asked if I wanted to go to Moscow. I said, "Moscow? Like in Moscow, Russia?" He helped me secure a place with a group of students who were awarded grants from Nikon and Time/Life magazines to travel to Russia and work on a photo project. I decided to seek out and photograph musicians who were living in the difficult economic culture of post-Communist Russia. I called what friends I still had in the music business and made some contact with Russian émigré musicians in New York City. They put me in touch with players they knew in Moscow, and when I got to Russia I hit the ground running. The students with whom I was traveling were much younger than I and had not so serious an agenda when we got to Moscow. I didn't speak the language, couldn't read the signs (which were written in the Cyrillic alphabet), and felt totally isolated in an alien environment. The grant sponsors had arranged for each of us to have a guide from Moscow University, who was of some help, but the guides were as interested in having a good time as the other students with whom I was traveling. So, after having gotten the photos of the musicians that I wanted, I joined them, and the experience was transforming. We walked around Moscow and other nearby cities and just shot whatever grabbed our attention—and we had to be sneaky about it. I developed skills at street photography that proved invaluable over the years. When I returned from the trip I was so buzzed from the high of living life as a photographer that I was burning for a chance to do more of the same kind

of work. Mario pushed me to come up with projects that I could pursue with a unique perspective that might be marketable.

In July 1991 I had returned to Sunset Park to see Bill Monroe perform. He was happy to see me after so many years. Thoughts of him and the life I led during my tenure with him and afterwards haunted my daydreams. And then I had an epiphany.

Back to Monroe, Bluegrass, and the Violin, 1991–96

E xcited to explore possibilities to play with my camera and my newly
discovered photographic talent, I returned to Sunset Park in July 1991
to say hello to Bill Monroe after a twenty-three-year hiatus from bluegrass
music. I drove down to Philadelphia to meet my friend and former Bluegrass
Boy banjo player Winnie Winston, and we headed on to West Grove. I hadn't
seen Winnie for quite a few years, so we had some catching up to do dur-
ing the drive. We talked about our old bandmates—David Grisman and Jody
Stecher—and about what was happening with bluegrass in the music industry,
and of course about Monroe. I had some trepidation about seeing him after
such a long time—would he even remember me, and if he did, would he be
welcoming? Winnie assured me that I had nothing to worry about.

As we entered the park my anticipation grew and my stomach fluttered. The
ticket seller at the gate recognized Winnie immediately, and when he started to
introduce me the ticket man said, "I remember you, you're one of Bill's boys,"
and he waved us through. I began to feel giddy with excitement. After we
parked the car, Winnie brought me to the park owner, Lawrence Waltman, who
remembered me right away and asked if I was going to play a couple of tunes
with Bill on stage. I hadn't touched a fiddle in over twenty years. Mr. Waltman

walked us to the band bus parked behind the stage and introduced me to the current generation of Blue Grass Boys—Dana Cupp, banjo player; Tom Ewing, guitarist; "Tater" Tate, bassist; and Jimmy Campbell, fiddler. Then I saw Bill chatting with a few fans and walked up to him, camera in hand, and started snapping photos. Bill looked with a characteristically myopic and quizzical look at this crazy guy with a beard and ponytail who was taking shot after shot while circling him, but he didn't recognize me. Then I said, "Hey Bill, remember that Jewish Bluegrass Boy from New York City?" He broke into a wide grin and put his hand out for me to shake. He had an old routine when greeting someone of whom he was fond: when I took his hand he pulled me off balance towards him as if to say, "I may be the old man, but I'm still stronger than you." He put his arm around my shoulder and gave me a squeeze. I felt a warm glow spread through me, and all the tension dissipated. Off to the side I noticed Winnie standing with the other band members watching us and smiling. That was a very special moment for me. I remember thinking how silly it was of me to imagine that Bill would ever hold me at arm's length. I hadn't yet started to play fiddle again, nor had I begun to formulate my plans for a photo project. I was just there to see my old mentor and have a good time (21).

The trip to Moscow was to be in September 1992. In the time I spent with Mario Cabrera during the summer before I went, I talked a lot with him about my Monroe experiences, and it became clearer to me what I wanted to do. I wasn't at all sure Bill would let me; he had always been a very private man. On July 5, 1992, I once again drove to Sunset Park to see Bill perform, this time with the germ of an idea in my mind. I mentioned the possibility of photographing Monroe to Tom Ewing and Dana Cupp. They both suggested that I not say anything to Bill; I should just shoot the photos. After the first show, I sat on the bus with Bill. We talked about music and what I was doing with my photography. I'm sure he wanted me to tell him that I was playing music. He was in his early eighties and had mellowed quite a bit since my days with him. I had a beard and long hair that I wore in a ponytail. I thought I'd be in for some needling from him, but he didn't say a word about it . . . at that time.

When he started to warm up for his second show, I went out front to get a seat close to the stage so I could get some intense shots of him. In the middle of the set he leaned over to Tom Ewing and said, "What's the Jewish fiddler's name?" He introduced me as a Bluegrass Boy alumnus and asked me up on stage to play a fiddle tune. I hadn't touched a fiddle in years, but some friends with whom I had traveled to the park took my camera away, pushed me up

onto the stage, and Jimmy Campbell, Bill's fiddler, gave me his instrument. I looked anxiously at Dana Cupp, who whispered, "We ain't gonna let you stumble." I played "Bill Cheatum"—the first tune I played on the Opry in June 1965. It felt strange to play fiddle, to be on stage, and especially to be with Bill again. But it was exhilarating! I didn't play too well, and as I shook hands with Monroe during the applause, he said to me, "You need to practice, shave, and get a haircut" (22). After the show, Bill's road manager, Jim Bessire, mentioned that Monroe would be in the Washington, D.C., area in August to play a show at Wolftrap Farm. I told him I'd meet them there.

That show was a package of bluegrass bands and individual performers that had been put together to perform along with a country band. Doc Watson and J. D. Crowe and his band the New South were scheduled to perform also. Ever since my days as a young banjo player, I'd been a fan of J. D.'s. He had a unique style of playing bluesy banjo licks, and I loved his sound when he played with the quintessential Jimmy Martin band with Paul Williams on mandolin. I looked forward to meeting him, and when I saw him in the dressing room, I stuck out my hand and said, "J. D., I've been a big fan of yours for years. My name is Gene Lowinger, I used to play. . . ." He jumped in before I could finish and said, "I know who you played for. You were Monroe's fiddler for the only show that I ever played banjo for him, in Lexington, in 1965." Then I remembered: it was during the weeks after Don Lineberger left the band and before Lamar Grier joined us (23).

I shot a lot of film that day at Wolftrap Farm, but I didn't want to use a flash. I had to shoot from the stage wings, as there was no way to get into the audience from backstage. But I got some memorable pictures. I saw Bill and Doc Watson sitting quietly backstage just before they were scheduled to go on together. The lighting was perfect (24). Minutes later, when Bill and Doc were on stage, I realized that with Bill standing and Doc sitting, I'd never get a shot of both of them from the side where I stood, so I ran around to the other wing and got a picture of them performing together (25). After Bill and Doc performed, Bill went on with the Blue Grass Boys. At the end of the show, when Bill returned for an encore, he announced that I was backstage and invited me to come out and play a tune with them. He was determined to keep me on my toes and was going to continue to make me come out with him until I wanted to. By the time of the Wolftrap Farm show, I had shaved off my beard and borrowed a fiddle from a friend and had been practicing since Bill lit my fire at the Sunset Park shows. I played "Monroe's Hornpipe," and as we

walked off stage, he turned to this clean-shaven fiddler and said, "Good job." I smiled, and as we shook hands, I told him, "Two out of three ain't bad."

In April 1992, *Bluegrass Unlimited* magazine published a short article about me. Looking to capitalize on what recognition I might have garnered from it, I contacted the magazine and offered to shoot photos for them at festivals and shows if they would provide me with press credentials. That summer I attended one of the big extravaganza bluegrass festivals. The Winterhawk Festival in New York State had a wonderful lineup that year, and I wanted to reconnect with some people I'd left behind years ago after I stopped playing bluegrass. I packed up my camera gear and a sleeping bag and headed out, feeling the same kind of trepidation as when I had gone to Sunset Park earlier that month—not knowing if the people I wanted to meet with again after many years would remember me, and if they did, what kind of reception I'd get.

The first person I saw in the backstage area was a fiddler who had always been one of my idols, Vassar Clements. I extended my hand to him, and when I introduced myself, he said, "Well, after all these years it's about time we finally met." He hugged me, and that was the beginning of a friendship that grew over the next few years (26). While Vassar and I were chatting in the warmup room just behind the stage, fiddlers seemed to pop out of nowhere and join us: Richard Greene—the fiddler who replaced me in the Blue Grass Boys—was at the festival to perform with his band; Joe Craven, the masterful performance artist who played percussion, fiddle, and mandolin in the David Grisman Quintet; and Jason Carter, the fiddler for the Del McCoury Band. Barrett Bacall, a regular photographer of the Winterhawk Festival, saw five fiddlers standing around and *had* to take the picture (27).

Whenever Vassar performed in the New York area I would try to photograph him. The first time I saw him after the Winterhawk Festival was at a small club in New York State. At that show the musicians who accompanied him were from the New York area: Bob Harris, Vassar's favorite backup rhythm guitarist (and his recording engineer), and Steve Lutke on banjo. I went early to the show to meet with Vassar, and during the sound check he asked me to stand in various parts of the bar to tell him how well the sound system was working. Then he handed me his fiddle and said, "You play some notes for me so I can hear how that fiddle sounds in this place." Vassar was an old pro, quite adept at performing in the most awful places in the tiniest backwaters of the rural South, and it wouldn't matter a lick to him how good or bad the sound in the house was. He asked me to play a Monroe tune, "Something like 'Wheel Hoss.'" When Bob

Harris started chomping those chords behind me, I knew why Vassar called him the best rhythm guitarist in the business. After I played a few choruses, Vassar came up on the stage with his backup fiddle and played the twin fiddle part. Everyone who was standing around the bar stopped what they were doing to listen. During the show, Vassar asked me up on stage to play that tune, and then he wouldn't let me leave. He kept asking me what else I remembered, and for whatever tune I named, he played twin fiddle: "Panhandle Country," "Brown County Breakdown," "Good Woman's Love"—songs I hadn't played in more than twenty years came flooding back to me while I was standing next to one of the fiddlers that I had venerated when I was a young man. I was incredibly buzzed after the show. That night, when I said goodbye to him, Vassar urged me to get my hands on a fiddle. I just grunted.

A few months later, at a club in New Jersey where he was playing with a Grateful Dead spinoff band (Vassar was thriving on his reputation as fiddler in the Old and In the Way Band, which featured Jerry Garcia on banjo, David Grisman on mandolin, and Peter Rowan on guitar), I was with a friend having a bite to eat, and Vassar joined us. When he asked me to get my fiddle and join him on stage, my friend said to him, "Can you believe it, Vassar? He doesn't even have one." Vassar grabbed my arm and took me into the dressing room, where he had stashed his double fiddle case. He opened the case and took out his second fiddle. He said, "Here, take this one until you find one you like." I was flattered, but I had no way to get it home. I wasn't about to put it in a paper bag. But I did promise him that I'd get a fiddle and play with him the next time I saw him. I didn't move too quickly on that promise.

At that same Winterhawk Bluegrass Festival, I had the opportunity to re-connect with my bandmate in the Blue Grass Boys, Peter Rowan (28), and to meet Doug Green (29), of Riders in the Sky, who had been Monroe's guitar player for a while in 1967 and bass player for the summer months of 1969. I hadn't seen Peter since leaving Monroe's band, and while I was with the Blue Grass Boys my interactions with him were at best tentative. The reunion that afternoon at Winterhawk was warm and cordial, and after considerable catching up, he asked me what I remembered of the interaction between him and Monroe in their collaborative writing of "The Walls of Time." We discussed it briefly and moved on to other things, but over the years Peter has pointed out to me a number of times that I was the only person who could vouch for what he considered to be his substantial contribution to the song. Considering the prodigious output of both Peter and Bill over the course of their careers, it

seemed a small point to me as to what percentage they each had in the song's creation—but then, in my whole creative life I've written only one tune, a fiddle instrumental titled "Nobody Rides for Free."

Talking with Bluegrass Boy alumni is always interesting. I've found over the years that each individual's reference back to Bill is a significant reflection of Bill's influence on him. I met Doug Green for the first time at that festival, and we hit it off immediately. I'd never seen Riders in the Sky perform, so it was a pleasant surprise to be so entertained by Ranger Doug, Too Slim, and Woody Paul—King of the Cowboy Fiddlers. Their renditions of campfire classics from the cowboy movies of the twentieth century reminded me of Saturday-afternoon movie matinees and the Roy Rogers, Gene Autry, and Hopalong Cassidy serials on television in the early 1950s. I found the Riders' stage presence refreshing—they could seem so spontaneous in their interactions after presenting the same material and telling the same funny stories hundreds of times, the hallmark of gifted performers. At a recent show when I greeted Doug, the first thing he said to me was, "You know, Gene, this is the 5,239th performance of Riders in the Sky." (While preparing this book, I wanted to keep Doug on his toes, so I asked him to tell me what number performance the Winterhawk Festival was. He wrote back, "Man, you know how to challenge a guy!" But he got it: 2,590.) In the 1990s, when I made a trip to Nashville with a friend, I called Doug to suggest a lunch date. He said he'd like to get together that day, and we decided where to meet. Then he added, "But I just want you to know, Gene, that I'll be coming from my daily running workout, so I won't be able to wear my cowboy outfit."

My favorite local venue for bluegrass has been an annual festival in southern New Jersey over Labor Day weekend—the Delaware Valley Bluegrass Festival in Woodstown. It began as a gathering of fans of old-time string band music in Delaware—sponsored by the Brandywine Friends of Old Time Music—and grew extremely popular, due in no small measure to its careful oversight and the tenacious efforts of its management to maintain a family environment, which has become something of a rarity in the bluegrass culture of the Northeast. The summer that I saw the Osborne Brothers perform there was memorable because Mac Wiseman was scheduled that same day. On Mac's second show, the Osbornes joined him to do some outstanding trios. The most memorable was "'Tis Sweet to Be Remembered." Mac had a way with slower tunes that would wring tears from a marble statue. On one of the road shows, when I was a Bluegrass Boy, Bill Monroe shared the spotlight with Mac. Since Mac didn't

travel with his own band, he asked Bill if he could borrow us for his show; Bill readily agreed. In about ten minutes he ran through his personal arrangements of some bluegrass standards that he liked to perform, and he expected us to pick them up right away. He was one of the first-generation pioneers of bluegrass music. When Lester Flatt quit Monroe's band, Bill hired Mac to sing lead, and the sound of Bill's music changed completely. The two songs that Mac recorded with Bill—"Can't You Hear Me Calling" and "Traveling this Lonesome Road"—were seminal works in the development of Monroe's high lonesome sound, which Bill continued to develop with lead singers such as Jimmy Martin and Ed Mayfield. So it was quite a treat to perform with him.

The most popular club in New York City for bluegrass bands was a nightclub in Greenwich Village that was directly across the street from where the once-famous Gerde's Folk City was located. In 1992, while I was still working at my once-in-a-lifetime day job, I had a chance to see Roland White perform there with the Nashville Bluegrass Band (30). This was yet another of my peripheral forays into the world of bluegrass music to "test the waters." The last time I'd seen Roland was at an all-night bash that Tex Logan threw for Bill in 1968 when Roland was playing guitar for Bill. He later went on to play mandolin for Lester Flatt and for Country Gazette before joining the Nashville Bluegrass Band. At the time the picture was shot, Roland had become one of the elder statesmen of bluegrass music.

That summer my mind was on its way to Russia. In September I was off to Moscow for ten memorable days of intense photography, and when I returned I was completely focused on developing film and making prints of the project for the trip sponsors. I wanted to impress them with my skills in the hopes of getting work as a photojournalist, so I produced a portfolio of twenty of my best shots and presented them to the *Time* magazine editor who was reviewing our work. He was impressed, was supportive of my ambition, and offered some helpful suggestions, but no jobs. I did, however, get a chance to exhibit some of my prints at a gallery in New York's SoHo district, a hotbed of art-gallery activity in those years. I took great pride in having gotten the invitation to show at that gallery. I learned some important lessons from that show and others that followed about coming to terms with my creative instincts. Discovering that I had the inclination to visual art so late in life was accompanied by serious doubts about my ability to see it through to actualization. At Mario's suggestion, I read books about the "greats" of photography—especially W. Eugene Smith—and talked to Mario about what I'd read. He encouraged me to go to

museums, galleries, or wherever photographs were exhibited to see works of the masters and to read anything they wrote about how they approached their work. I started to realize that to take great pictures, the most important thing is to have a camera with me all the time. My friends teased me about it, but I got some great shots that otherwise would have had me saying to myself, "Damn, I wish I had my camera with me!" As for the intellectual opinions that I read about the work of famous artists, Mario told me, "Forget that stuff. Just go out and shoot."

Towards the end of October I needed to get away from the darkroom, so I called Jimmy Buchanan, fiddler for Jim and Jesse McReynolds, who invited me to stay at his home in Hendersonville, Tennessee, near Nashville. I wanted to reconnect with the McReynolds brothers, Bill Monroe, and others in the bluegrass business in the hopes of getting them interested in my photography. In the last weekend of October I took a break from processing my Russian photos and drove down to Nashville.

I went with Jimmy to the Grand Ole Opry that weekend. It was my first time in the new Opry house. There were pictures and mementos of the old Ryman Auditorium all over. I took this shot in the "bluegrass" dressing room. Just to the left of Jim Buchanan's head you can see a photo of Bill Monroe wearing the outfit of the original Blue Grass Boys: jodhpurs and high-top riding boots (31). When I met the McReynolds brothers that evening, we reminisced about the old days when I played on the Opry at the Ryman. That tickled me, because when I was cutting my teeth on bluegrass *they* were the old timers of bluegrass music. Jesse talked about the early days of playing bluegrass music. It wasn't called "bluegrass" in the late 1940s and early 1950's; it was just a style of country music. Jesse told me that when Bill first brought his driving sound to the Opry with Earl, Lester, and Chubby Wise, it was a sensation. Nothing like it had ever been heard before, so naturally there were spinoff bands. Although the McReynolds brothers used similar instrumentation, their sound was distinguished by silky smooth singing in the brother duet style of the Louvin Brothers, the Delmore Brothers, and the Blue Sky Boys—quite different from the high-powered overdrive of Monroe's sound. (Monroe recorded in that brother duet style with his brother Charlie in the late 1930s. It was after they split up that Bill made a conscious effort to begin developing his own unique style.) Over the years there was some turnover in the McReynoldses' band members, but I always remember the classic Jim and Jesse sound of Allen Shelton on banjo and Jimmy Buchanan on fiddle. The brothers were always trying new ideas and

testing new waters. One of the most outstanding memories I have of seeing them was at Sunset Park in June 1992. The audience at that park was generally very traditional in their tastes, a very down-home country crowd. During the second show the McReynolds Brothers did a tune they had recorded on their tribute to Chuck Berry album, "Johnny B. Goode." By the time they got to the first chorus the entire audience was *rockin'!* Fifty- and sixty-year-old farmers and their wives were up on their feet clapping along and boogying.

That first trip back to Nashville was an opportunity to stroll around down-town, which, in the years since I'd left, had gone through a dramatic change for the worse once the Opry moved out to Opryland on the outskirts of town. Just after that visit, the Ryman Auditorium was rehabilitated and modernized, shows were booked, and that entire area of Nashville became revitalized and gentrified. I stopped into Ernest Tubb's Record Shop, where sidemen from the Opry would often go to perform after the Friday- or Saturday-night Opry broad-cast. I went to Hatch Show Print, which had an archive of old show posters for all the country performers from the Opry. I was surprised to see Tootsie's bar (32), and the back room, which was the hangout for all the country per-formers who would go right from the Opry stage door into Tootsie's, was still there. I had a chance to visit the Ryman Auditorium before the renovations of the new stage and backstage area. It was wonderful to see all the photos and memorabilia hanging there and to see the dressing room that the Blue Grass Boys shared with other Opry stars (33). That was a very democratic time at the Opry. At the new Opry house many of the more famous celebrities have their own rooms, and there is one catch-all "bluegrass/traditional music" room.

At the beginning of August 2007 I noticed an advertisement for a local blue-grass festival held every year on Staten Island. Jesse McReynolds was billed as the headliner. I sent an email to him hoping to find that Jim Buchanan would be with him on that road trip. I got a response back from his wife, Joy (a former fiddle student of mine), who said that Buchanan would not be able to make the trip and that Jesse wanted me to play fiddle for him on those shows. I was flattered that he asked but reluctant to do it because I hadn't played serious blue-grass in a while. I knew his repertoire to listen to, but I didn't have any of the tunes in my fingers. When I told this to Joy, she wrote back that Jesse said not to worry—whatever I did would be fine, and he was looking forward to seeing me. A couple of days later I got a CD in the mail on which Jesse had recorded all the tunes that he was planning to do that day. I had to start sawing wood. The toughest piece in the shows was an instrumental, "El Combanchero,"

which Jesse plays faster than greased lightning. I spent most of my practice time trying to work out something reasonable for it, and when I got together with Jesse the day of the show, he told me that almost none of the fiddlers he works with ever take a solo on that piece. We tried it out, and it seemed okay. Jesse said that if it was too fast on stage, or if I didn't feel confident enough, just give him a sign, and he'd jump back in. I was having a wonderful time on stage that day. Some of my friends and relatives had come to the show to see me play with him. I felt my way through the arrangements we'd gone over in the dressing room before the shows, and the musicians in the band—which included two of Jesse's grandchildren—played wonderful backup. When that tune came up on the set list, Jesse looked over, smiled at me, and ripped into it. My palms were sweaty as I played along with Jesse to see if I could get my fingers to move that fast, and before I knew it, I was up. I tore through the solo without thinking about a note, tripped up once or twice, but on the whole I made it. When the solo was over, the audience responded warmly, and the perfectionist in me wanted to do it again, better.

After that first trip to visit Jim Buchanan I took a long break from my blue-grass photo project. I needed to get some work at home, so capitalizing on my Russian expedition, I began doing photography for an immigrant-aid organization that sent me to Kennedy Airport several times a month to photograph immigrant arrivals as they came out from the gate into their new lives in America. Between that and following through with some Russian families who settled in Brighton Beach, Brooklyn, I was busy most of the winter and into the spring. Then I saw an ad that listed Bill Monroe performing on June 27 in a park in Huntington, New York, which was quite a distance from me. But I thought this would give me a good chance to pick up with him where I'd left off the previous year. I drove to the show, and after I spent that evening with Bill, I mentioned to Tom Ewing that I wanted to travel with the band on the bus for a few short road trips so I could get informal nonperformance shots of Bill. Tom told me about several short road trips that were coming up during the summer and suggested that I come down, and he'd get me on the bus. When Bill played the Huntington show, Ernie Sykes played bass for him (notice Ernie's "Three Stooges" necktie). I had to grab this shot quickly to get the hats lined up just right (34). The point of the peghead on Bill's mandolin reminded me of how he would stand behind me when I took solos and stick me in the back to remind me he was there, and I'd better play well (35). I still think of that point when I play any kind of music, always sticking me in the back to do better.

I flew down to Nashville in the beginning of July. In the early morning hours of July 9, Tom Ewing and I drove to the office of Monroe Enterprises, where the tour bus was waiting to take us to Denton, North Carolina, for the Doyle Lawson Bluegrass Festival. Once everyone was settled on the bus, I began shooting to capture the atmosphere of life on the road. It's not as glamorous as what most people might imagine. The space is cramped, and it's impossible to stay out of each other's way. Road trips are tedious and draining. The food for the most part was the same as when I was a Bluegrass Boy—terrible truck-stop fare. We stopped to eat before sunrise. I had been taking photos the whole time we were traveling, and it was just as I'd wanted it to be. Bill paid no mind to me and acted as if I were just another Bluegrass Boy on the trip. I sat across the booth from him as he ordered his breakfast of eggs, biscuits, ham steak, and hash-brown potatoes. I had a super wide-angle lens on my camera, so even though I was only three feet away, I could get the whole scene of Bill and the diner. I thought I was being so inconspicuous taking photos of Bill with my Leica. Sometimes I talked to him, held the camera away from my face, and "zone" focused to get the shots. But I couldn't fool the old fox; he just didn't care that I was shooting him (36). Just when I was thinking that I was in photojournalist heaven, Bill looked up from his food and asked, "You gettin' some good pictures?" He really enjoyed talking to small children and giving them quarters to remember him by (37), and he posed some shots for me, like when he grabbed the waitress and kissed her (38).

After breakfast Bill got back on the bus, and once we were under way, he discussed the business for the day with Jim Bessire, his road manager (39). That day was intensely hot, and even with the air conditioning backstage working overtime, everyone was soaked with perspiration. During the time I worked for Monroe, he never once showed any reaction to the heat, never perspired, never took off his jacket while warming up for, or during, a performance. That day he and the band went down to their shirtsleeves (40). Some fans and local celebrities stopped back in the dressing room to say hello to Bill, and being the gentleman that he was, he never missed an opportunity to help a young lady, this time with a mandolin lesson and a dance (41, 42). In spite of the heat, Bill put everything he had into his shows, clowned around with me (43), and still had some energy to do a buck dance during a fiddle tune (44). By the end of his second show that day, he was so exhausted he had to be helped offstage (45).

It was well after midnight by the time we were ready to head back. Once under way, Bill changed back into his "bus" clothes and settled in for a night trip

of playing solitaire and dozing, always with a box of glazed donuts within easy reach (46, 47). He was scheduled to play the afternoon of July 10 in Murfreesboro at a small festival and then head back to Nashville to play two performances on the Grand Ole Opry. He didn't get much rest that weekend, but his energy never flagged. The Blue Grass Boys got off the bus in Nashville, intent on going home for a few hours and making their own way to the afternoon gig. I stayed on the bus with Bill (48). When we got to the show, Bill mingled with the crowd and said hello to some fans who had been faithful to him over his more-than-fifty-year career (49). He met his old friend and dancing partner, Jackie Christian. He loved to dance and show everyone that he could still "cut a rug" (50). That night on the Opry, Bill was warning up in the Opry dressing room, fresh as a daisy; in the background sitting along the wall was Wilma Lee Cooper (51). The back wall of the rehearsal room is one long mirror, and it is nearly impossible to get a good shot in that room with a flash. Once again, my Leica M6 came to the rescue (52). While he sat on the couch, I asked Bill to play something on Tom Ewing's guitar (53). On the wall above Bill's head is a picture of Stringbean. I had taken so many performance shots of Bill that day and the day before, I was not on my toes during his Opry performance that evening. But just at the right moment I happened to get the camera up for a great shot (54).

Two weeks later I traveled to Nashville again for another short road trip. On July 23 I met up with Bill at the office of Monroe Enterprises, where he usually stopped in a few times a week to sign papers. He showed me his 1993 Grammy Lifetime Achievement Award (55, 56), and he took me for lunch to his favorite restaurant, Mason's, near his farm (57). Then we headed to his home for the afternoon, where he gave me a tour of his cabin (58). One of Bill's hobbies was collecting memorabilia about his career and plates from every state in the Union, which he hung in his kitchen (59, 60, 61, 62).

Later, as we were walking around the farm, when he asked me why I wanted all these pictures, we got into a conversation about my photojournalism work. He asked me if that was what I really wanted to do, and I saw that I was in for a heavy conversation. We talked about Professor Bronstein and his musical ideas. Bill, with a whimsical sound to his voice, said, "Is that right?" or, "That's what I think, too." I told him about the accident I'd had and the physical problems as a result of it, about my job at the bank and how dejected I had become during those years. I'm pretty sure, knowing Bill as I did, that he had an inkling

of the problems I was having with drugs and alcohol but didn't quite know how to bring up the subject with me. And then at one point he stopped walking and looked off into the distance, deep in thought. He turned to me and said, "I never did understand why you left the band when you did." We talked for quite a while about it, which surprised me, because the Bill Monroe I was familiar with was not a prodigious conversationalist. Then he said, "It's really too bad you left me when you did. I always thought you could have really been something if you'd stayed with music." I was speechless for a few moments, and then I said to him, "Bill, you never said anything like that when I was playing for you." He kind of screwed up his brow for a second and asked, "Would it have made any difference?" That ended that. Then he asked me what I was going to do with all the pictures I was taking of him. I told him of my plans to possibly write a book that would include them, and he said that was a fine idea and asked if I could make any money from it. Would that help me to get back to playing music? He said, "I take you boys into the band with me to teach you how to play music right. And I need all of you to go out and do it the way I showed you." I promised him I would. That was the second promise I'd made to take up the fiddle again. God was pushing this stubborn fiddler along.

That evening, as he was walking up to the backstage entrance door to the Opry, Bill gave me my very favorite picture I ever took of him. Just as I was ready to snap the shutter he picked up his hand to cover his face with a promotional photo of himself he'd been carrying. That shot speaks volumes about Bill. He had a sense of humor and playfulness. I had just spent a good part of the day with Bill Monroe, the private man, been to his home and got photos of him with his pets, in his kitchen, and getting ready for the Opry. When he pulled that stunt, it was if he were saying, "That's it for today, that's all you're getting of me. From here on, it's my public face" (63).

Bill's weekly routine at the Opry was to stop at his mailbox and take his fan mail to the rehearsal room to read before warming up for the show (64, 65). The next day, July 24, we went up to Lexington, Kentucky, and on the way, Bill conferred with Dana Cupp, his banjo player, about a song that he'd been working on (66). He did a quick warmup (67), played the show (68), and afterwards met with fans to sign autographs (69), and then it was on the road again, this time to Wolftrap Farm in Virginia for a show on July 25.

Before the show at Wolftrap, Bill, Del McCoury, and Del's wife Jean spent some time with Porter Church, who had played banjo and guitar with the Blue

Grass Boys in 1960 (70). That was a wonderful night of music highlighted by Del's and Bill's performances, and Bill's reception was outstanding. It was truly heartwarming to hear the response he got from the audience, and he unabashedly basked in the glory (71, 72).

I saw Bill a few more times after that, and played with him on those shows. On August 24 he played as part of a series of outdoor folk-music concerts in the Damrosh Band Shell of Lincoln Center in New York City. I went to photograph him, but he asked me before he went on stage if I wanted to play a tune with him. He wanted to show me off to what he considered to be my hometown crowd. We decided that I'd play "Big Mon," a tune I had practiced in anticipation of his asking me to play. Then he called me out on stage, asked me a few questions, and leaned over to Tom Ewing and asked, "What should we play?" Tom must have been feeling a bit mischievous that night. He knew we were planning to do "Big Mon," but he told Monroe "Uncle Pen." Bill announced it to the audience and smiled at me. Tom smiled at me, and I heard Dana Cupp chuckling in back of me. I had been snookered. "Uncle Pen" is a great tune for showing off the fiddler of a band, but it is *not* one that rolls effortlessly from the fingers. I got through it, and then we did "Big Mon." After the show, when I shook Bill's hand, he said to me, "'Uncle Pen' is a fine tune. Every fiddler should know it." The next week I saw Bill in Sunset Park, and once again he asked me on stage to play a tune with him. Once again, when I picked up the fiddle, he leaned over to Tom and asked, "What should we do?" And again Tom said "Uncle Pen." But I was ready. I'd practiced it all week, and I ripped it off. That excited Bill. When I played "Big Mon," he walked over to where I was playing, stood right behind me, and chopped chords on his mandolin, pushing me along, driving the band, and letting me know how proud of me he was (73). Bill had been performing at Sunset Park for many years and had acquired quite a following there. He deeply appreciated the fans who always showed up to hear him over the years (74). After the evening performance, I got the whole band to pose for a group shot: the final iteration of the Blue Grass Boys (75).

That was the last time I saw Bill Monroe. He continued to tour and play the Opry for another two and a half years. The last time he performed on the Opry was March 15, 1996. The next day he had a minor stroke and was taken to Baptist Hospital in Nashville. While recovering there he had a major stroke on April 5. He was moved to a nursing home, where his close friends and musical associates visited him, and on September 9 he passed away. His funeral was

on September 12 in Rosine, Kentucky. I remember the day he died. I closed myself up at home and listened to his mandolin tune "My Last Days on Earth" about a hundred times. I cried for the passing of a great man in the history of American music and was filled with thankfulness for having had the honor of knowing him, playing fiddle in his band, and for having the great privilege of calling him my friend.

21. Bill Monroe at Sunset Park, Pennsylvania, July 14, 1991.

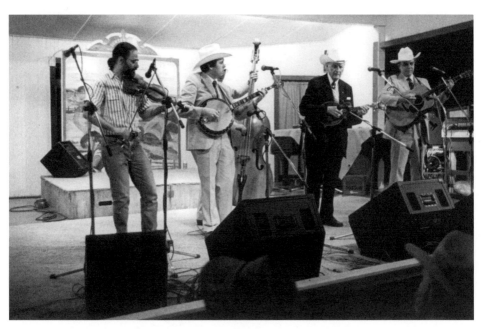

22. Gene Lowinger and Bill Monroe at Sunset Park, Pennsylvania, July 5, 1992.
© Laurence Kesterson, used by permission, all rights reserved.

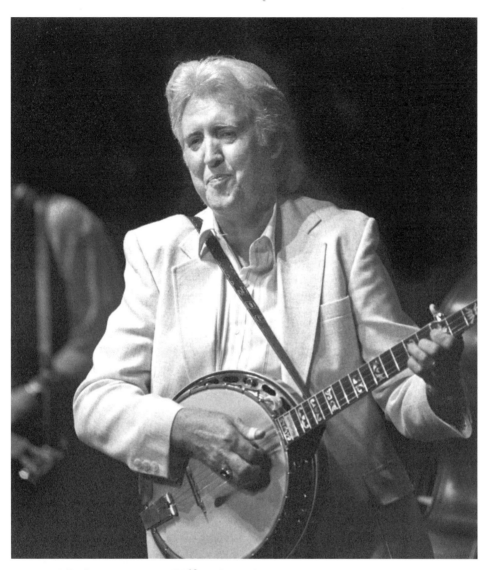

23. J. D. Crowe on stage at Wolftrap Farm, August 22, 1992.

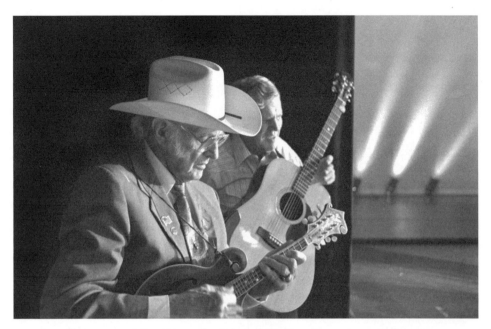

24. Bill Monroe and Doc Watson backstage at Wolftrap Farm, August 22, 1992.

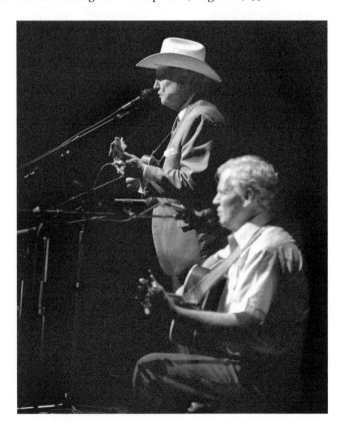

25. Bill Monroe and
Doc Watson on stage
at Wolftrap Farm,
August 22, 1992.

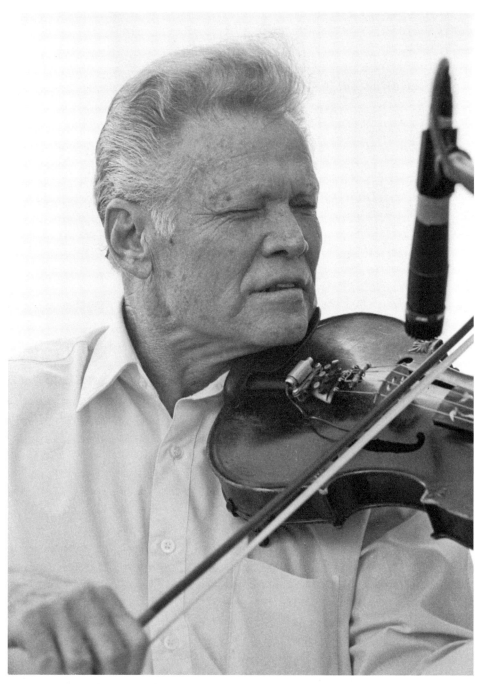

26. Vassar Clements at the Winterhawk Bluegrass Festival,
Ancram, N.Y., July 19, 1992.

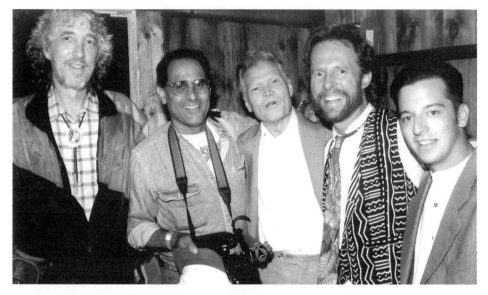

27. The fiddlers backstage at the Winterhawk Bluegrass Festival, Ancram, N.Y., July 19, 1992. Richard Greene, Gene Lowinger, Vassar Clements, Joe Craven, and Jason Carter. © Barrett S. Bacall, 2001, used by permission, all rights reserved. Converted from color.

28. Peter Rowan at the Winterhawk Bluegrass Festival, Ancram, N.Y., July 19, 1992.

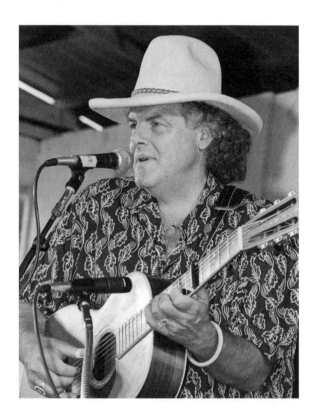

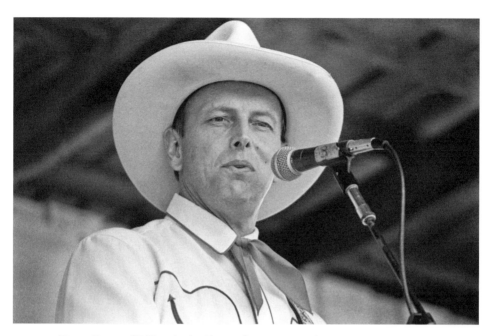

29. Doug Green of Riders in the Sky, performance number 2,590, at the Winterhawk Bluegrass Festival, Ancram, N.Y., July 18, 1992.

30. Roland White at the Bottom Line, New York, May 12, 1992.

31. Jim Buchanan and Jesse McReynolds backstage at the new Grand Ole Opry House, 1992.

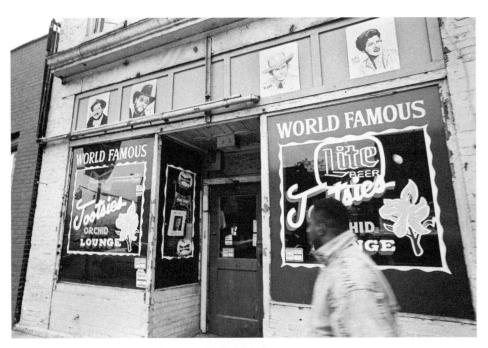

32. Tootsie's bar on Broadway, Nashville, November 2, 1992.

33. Dressing room that Monroe used at the Ryman Auditorium, Nashville, November 2, 1992.

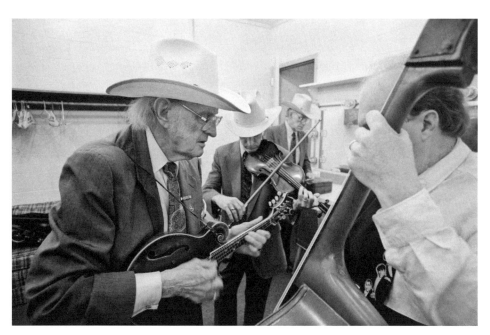

34. Bill Monroe backstage at Huntington, N.Y., with Robert Bowlin, fiddle; "Tater" Tate; and Ernie Sykes, double bass, June 27, 1993.

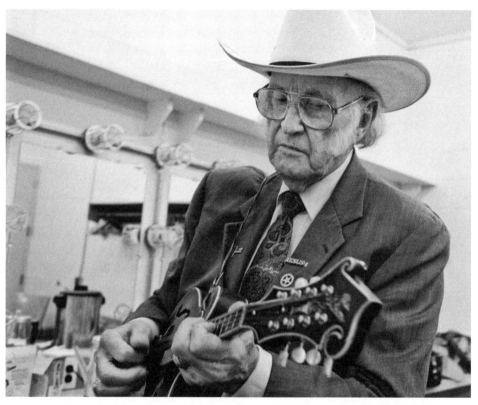

35. Bill Monroe backstage at Huntington, N.Y., June 27, 1993.

36. Bill Monroe at a truck stop on the road to Denton, N.C., having his usual breakfast of ham and eggs and hash-brown potatoes, July 9, 1993.

37. Bill Monroe at a truck stop on the road to Denton, N.C., giving a quarter to a young fan, July 9, 1993.

38. Bill Monroe at a truck stop on the road to Denton, N.C., with a waitress, July 9, 1993.

39. Bill Monroe with his road manager, Jim Bessire, July 9, 1993.

40. Bill Monroe backstage at the Doyle Lawson Festival, Denton, N.C., July 9, 1993.

41. Bill Monroe backstage at the Doyle Lawson Festival, Denton, N.C.,
July 9, 1993, giving a mandolin lesson to a young fan.

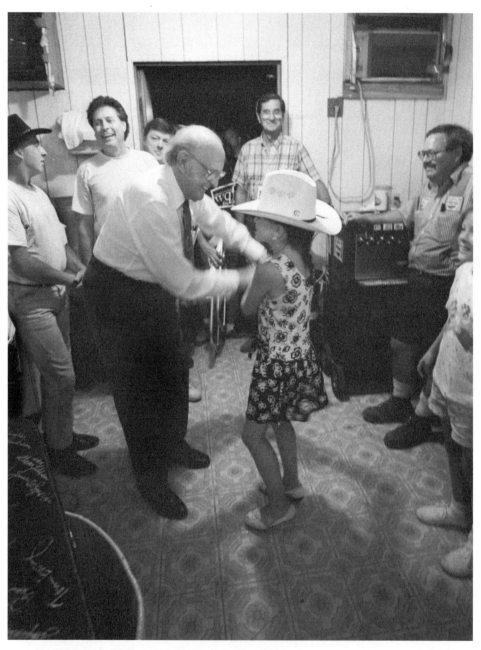

42. Bill Monroe backstage at the Doyle Lawson Festival, Denton, N.C., July 9, 1993, dancing with a fan.

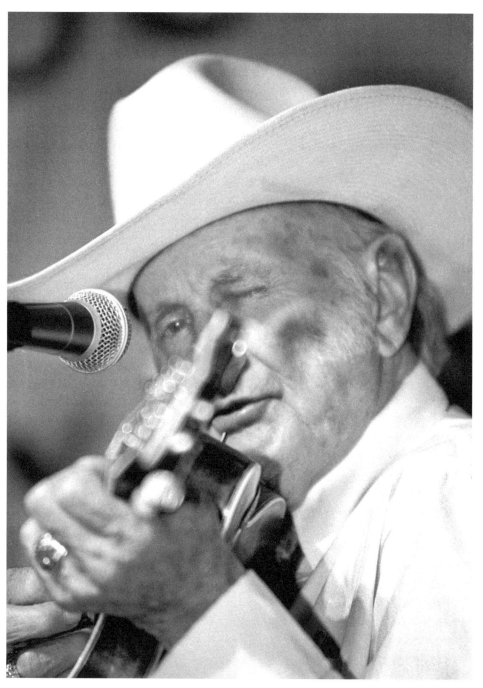

43. Bill Monroe at the Doyle Lawson Festival, Denton, N.C., July 9, 1993.

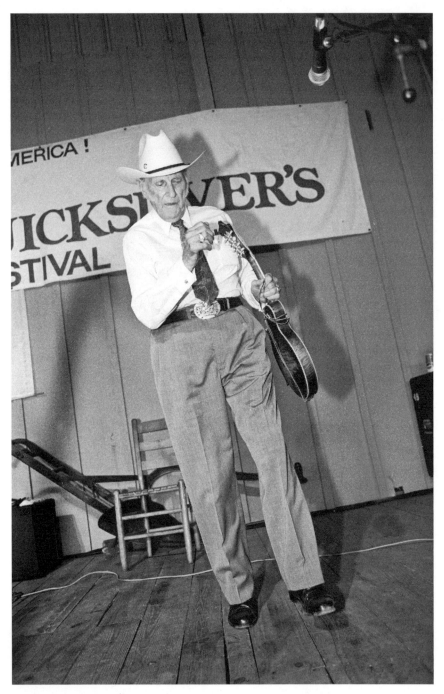

44. Bill Monroe performing a buck dance at the Doyle Lawson Festival, Denton, N.C., July 9, 1993.

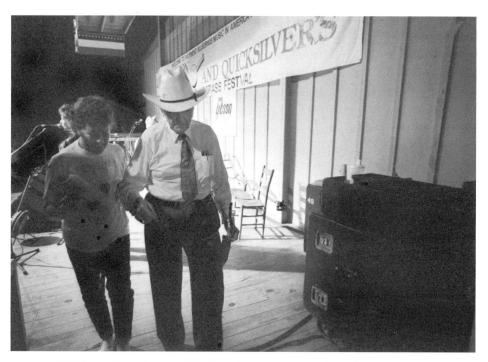

45. Bill Monroe being helped offstage at the Doyle Lawson Festival, Denton, N.C., July 9, 1993.

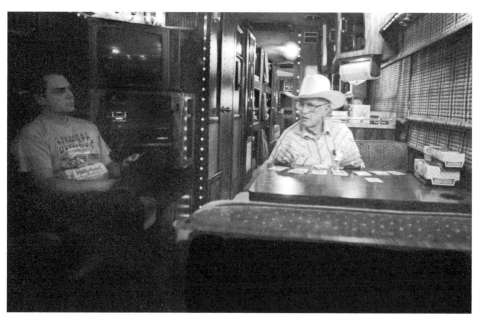

46. Bill Monroe and Tom Ewing on the bus heading back to Nashville, playing solitaire in the early morning hours, July 10, 1993.

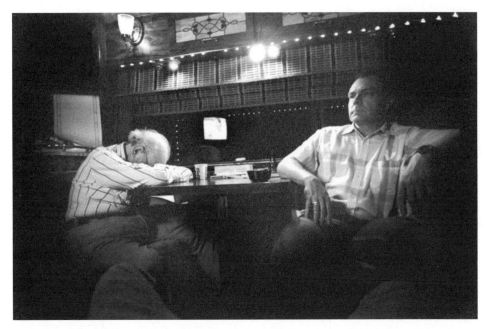

47. Bill Monroe on the bus catching some sleep, Tom Ewing watching TV, heading back to Nashville, July 10, 1993.

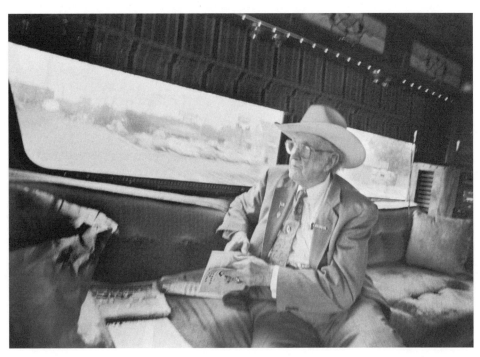

48. Bill Monroe traveling to Murfreesboro, Tennessee, the afternoon of July 10, 1993.

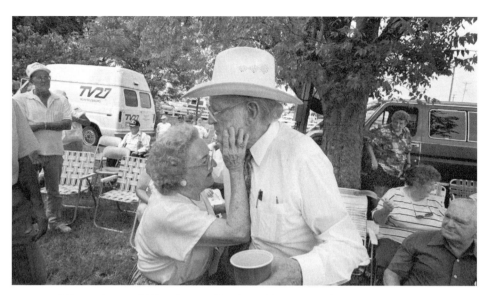

49. Bill greeting an old friend at Murfreesboro, Tennessee, July 10, 1993.

50. Bill Monroe dancing with his longtime dancing partner Jackie Christian at the Murfreesboro Festival, July 10, 1993.

51. Bill Monroe warming up in his dressing room at the Grand Ole Opry, July 10, 1993. Wilma Lee Cooper is in the background.

52. Bill Monroe and the Blue Grass Boys backstage at the Opry, July 10, 1993. Robert Bowlin, fiddle; Tom Ewing, guitar; Bill Monroe; and Dana Cupp, banjo.

53. Bill Monroe backstage at the Opry playing Tom Ewing's guitar, a Martin D28 from 1962 with added adornments, July 10, 1993.

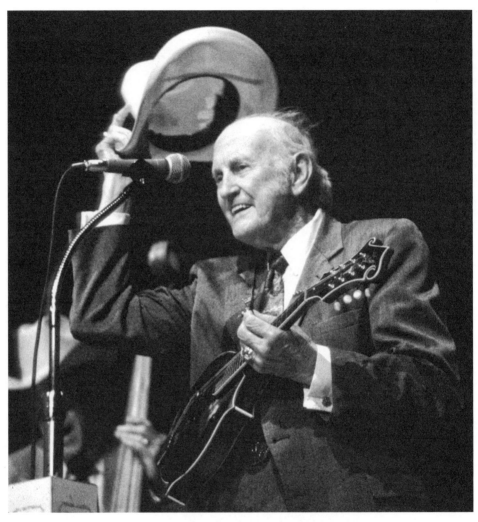

54. Bill Monroe on stage at the Opry, July 10, 1993. Converted from color.

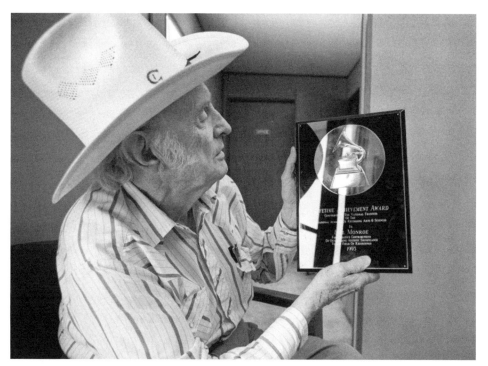

55. Bill Monroe at his office showing me his Grammy Lifetime Achievement Award, July 23, 1993.

56. Bill's Grammy Lifetime Achievement Award, July 23, 1993. Converted from color.

57. Bill Monroe at Mason's restaurant, Goodletsville, Tennessee, July 23, 1993.

58. Bill Monroe's house on his farm in Goodletsville, Tennessee, July 23, 1993.

59. Bill showing me memorabilia at his home, July 23, 1993.

60. Bill and his dog,
July 23, 1993.

61. Bill in his kitchen, July 23, 1993.

62. Bill getting ready to go to the Opry, July 23, 1993.

63. Bill walking into the Opry, July 23, 1993.

64. Bill reading fan mail backstage at the Opry, July 23, 1993.

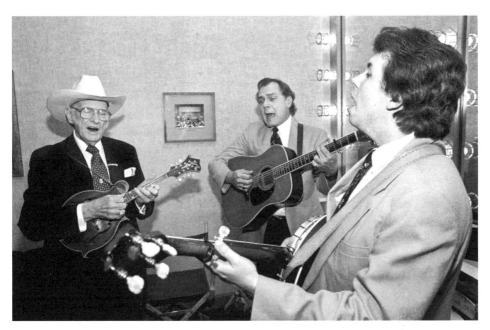

65. Bill Monroe, Tom Ewing, and Dana Cupp warming up at the Opry, July 23, 1993.

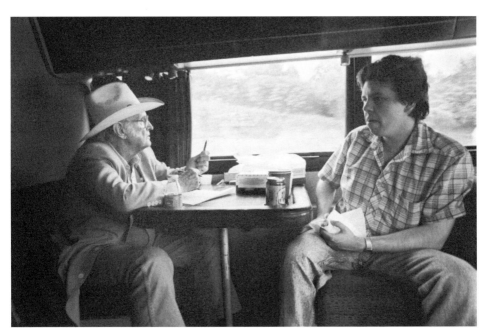

66. Bill Monroe and Dana Cupp working on a new song
on the bus to Lexington, Kentucky, July 24, 1993.

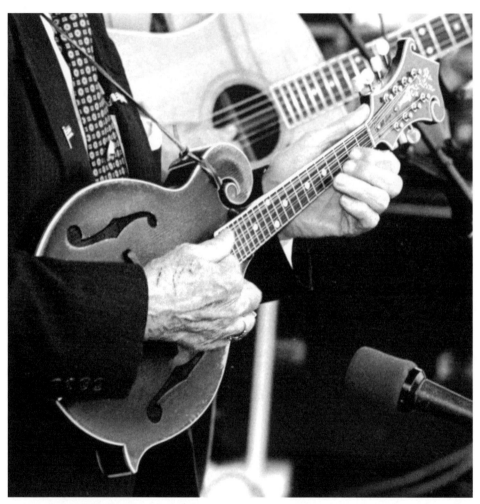

67. Bill with his restored Lloyd Loar Gibson F5 mandolin,
backstage at Lexington, Kentucky, July 24, 1993.

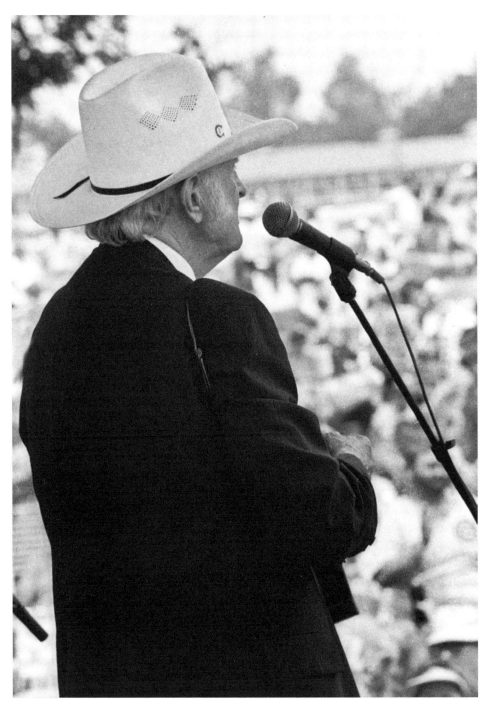

68. Bill performing at Lexington, Kentucky, July 24, 1993.

69. Bill signing autographs at Lexington, Kentucky, July 24, 1993.

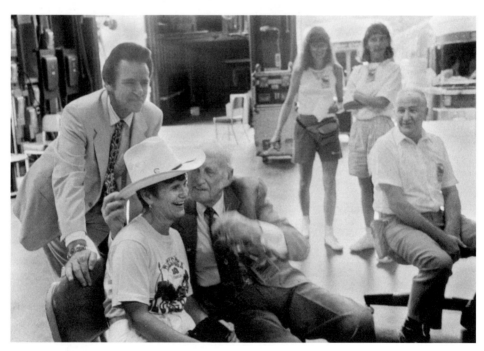

70. Bill Monroe backstage at Wolftrap Farm with Del McCoury, Jeannie McCoury, and Porter Church, July 25, 1993.

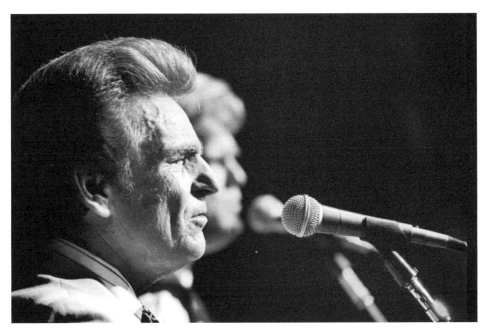

71. Del McCoury and unknown singer on stage at Wolftrap Farm, July 24, 1993.

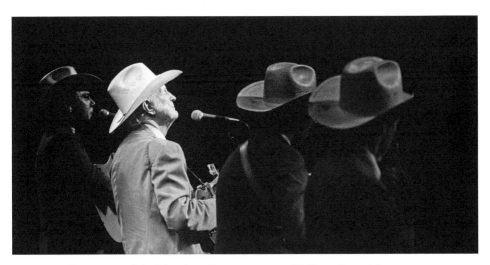

72. Bill Monroe and the Blue Grass Boys on stage at Wolftrap Farm, July 24, 1993.

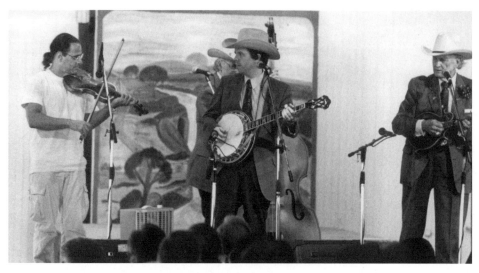

73. Gene Lowinger and Bill Monroe performing on stage at Sunset Park, Pennsylvania, August 29, 1993. Photo by Laurence Kesterson © 1993, used by permission, all rights reserved.

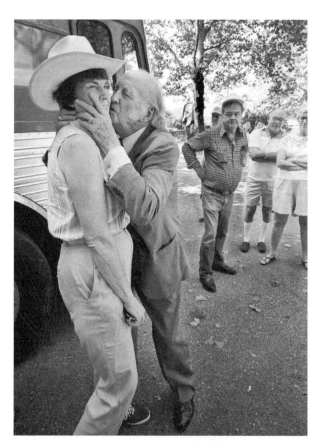

74. Bill with a fan backstage at Sunset Park, Pennsylvania, August 29, 1993.

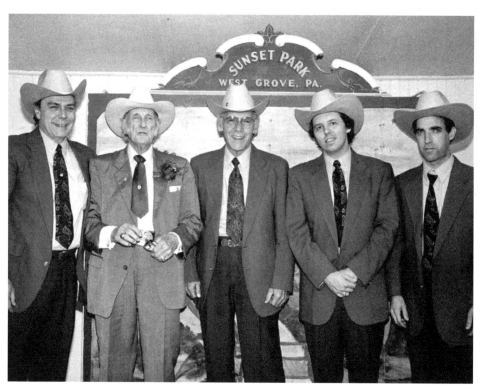

75. Bill Monroe with the last iteration of the Blue Grass Boys at Sunset Park, Pennsylvania, August 29, 1993. Tom Ewing, Bill Monroe, "Tater" Tate, Dana Cupp, and Robert Bowlin.

CHAPTER 6

After Monroe, 1996 to the Present

I still wasn't seriously working on playing the fiddle. My life was an endless
spiral of meaningless part-time jobs, and I was quickly reaching my bottom
with my drinking. I had stopped using drugs some years ago while I was work-
ing on Wall Street—an act of personal will, cold turkey. I believed likewise that
I could stop drinking whenever I decided to, but I was wrong. I didn't know it
at the time, but what I needed was a paradigm shift in my thinking and spiri-
tuality. So I started to work with some people who had the same difficulties as
I did. At about that time I met some local musicians who knew of me and my
experience as a Monroe fiddler. I told them my tale of woe, after which they
said that their band was playing two gigs that weekend, and I was welcome to
play fiddle. I'd be paid one hundred dollars. I went home and started to practice.
My playing on those two shows was rough, but they told me I was welcome
to play any jobs they booked. I started practicing in earnest and realized that I
needed a better instrument, so I called Vassar Clements. He suggested I come
down to Nashville, and he'd take me around to look at fiddles. But before I
made the trip I looked around home and found a really nice instrument at a
local violin shop. It had a clear, sweet tone, and I knew it would serve me well
no matter what kind of music I played. The next time I saw Vassar I brought

it with me, we played some twin fiddle tunes during his show, and afterwards he told me he loved the sound of my violin. I put it up to my ear, listened, and said, "I don't hear anything." He just nodded to me and smiled.

I played with that group for about a year and then formed my own band that did some work over the next few years. There was not a big market for local bluegrass bands in the New York area, and to keep a working band together was difficult under the best of conditions. When my friends urged me to throw myself into playing again I shuddered, knowing the commitment I would have to make to play to my satisfaction. Most importantly, I was afraid. To find that I still loved making music on the violin more than anything I've ever done and then to find that I still had physical handicaps would have been devastating. With the aid of an acquaintance who was helping me to get sober, and coincidentally was a jazz drummer, I was beginning to put my life together again. He too encouraged me to play, so I went at it. I needed to prove to myself that I could do it. At the time I was working as a part-time limousine driver, a job that sometimes required me to sit in the car at an airport for extended periods of time, waiting for delayed flights. I brought my fiddle with me, sat in the back of the limo, and practiced while I waited. But I had a problem with the bow being too long and the limo ceiling being too low. At the next trip to the violin shop, the owner gave me a quarter-sized child's bow, and it was perfect. Problem solved. I gathered together some musicians I really respected and recorded fourteen arrangements of traditional bluegrass tunes and instrumentals with the idea to produce a CD. The silence of the reception it received in the bluegrass community was deafening, but it was worth the effort.

The local violin dealer had arranged for some violin students, who were customers, to play for a classical master class, and invited me to join them. I had had the instrument in my hands for a few years already, and I had my bluegrass chops pretty well back in shape, but I hadn't played classical music for over twenty-five years. I was afraid to try again, for the same reasons as when I first picked up the instrument to play bluegrass after a long layoff: the physical barriers to be overcome. Professor Bronstein had passed away some years ago, but I had stayed in contact with his daughter, Ariana Bronne. She had been nudging me to come visit and play for her, so when the offer to play the master class came, I called her to discuss it, and my fate was sealed. We decided what piece I should prepare. I practiced for two weeks and met her to get down to work. We put the piece together (Mozart's Violin Concerto No. 5), and I played the master class, but not well: I got very nervous.

Ariana made the trip to New Jersey to hear me play, and after the class she told me that she wanted me to prepare two very difficult pieces: a movement of the Bach G minor unaccompanied violin sonata, and a Paganini Caprice. I looked at her quizzically and said, "You really think I can do it?" She said yes, and I began to practice with some trepidation. The effort has been worth it, and we continue to work together. She has been patient with me, critical but encouraging at the same time, taking me through the gamut of scales and technical exercises that were designed to develop muscle strength and control. Many times, after a difficult lesson, I would call my friend—the jazz drummer—and moan about how I had just been raked over the coals, how it seemed that I couldn't do anything right, how I was only torturing myself by thinking that I could ever recover what I once had. He would always tell me the same thing: of course she raked me over the coals; that's what teachers do. Of course I can do it. She wouldn't be bothering with me if she didn't believe I could. I should be thrilled that I had someone who was willing to put in the effort with me. Right from the first lesson she told me she loved working with me because I wasn't afraid to dig in and practice hours a day. I think she knew what it cost me to do that much hard work and wanted to encourage me as much as possible. Gradually, my playing improved. I tackled ever more difficult concertos, and the joy of meeting the challenge began to outweigh the fear of failure. I could feel Bill looking down upon me and smiling. Coincidence was not an issue; my spiritual life grew by leaps and bounds. I was relieved of the compulsion to drink, and my life in general began to glow again. Over the following years Ariana took me through a large chunk of the classical violin repertoire. I was a violinist again.

I wasn't getting my act together just to sit home and play for myself. An old friend from music school, who also had been a student of Ariana's, invited me to play first violin in a string quartet. I was excited to interact with other musicians. We rehearsed a few times a month and got some gigs at wedding receptions and dinner parties. Around the same time, I began playing in a local community orchestra. At the opening rehearsal I sat in the first violin section, and when I opened the folio there was a collection of some of the most difficult orchestral pieces in the repertoire, with notes in the highest register at the top of the fingerboard that need to be played faster than anything in bluegrass. I didn't do any worse than anyone else at that first rehearsal, and I wanted to do a lot better. So once again, I had my work cut out for me. And

once again, I absolutely loved it. I needed to be patient, hard-working, and let everything happen in God's time, not mine.

I have been blessed to know people who have cared enough to prod me along and invest themselves in helping me realize my potential. Now it's my responsibility to pass on to others the message that I was taught and to pay homage to the man who first showed me that it is okay to dream. I retired from my latest career as a part-time employee. Playing in a local community orchestra and as first violin in a string quartet and continually working with Ariana was taking up much of my time. Teaching violin became my next career, but I still had time on my hands, so I decided to work on my photography again. The world of photography had gone through a major shift since I last held a camera. I already owned a tiny point-and-shoot digital camera smaller than a pack of cigarettes, but the quality of the images was so bad that I'd had no incentive to do anything with them except put them into a digital scrapbook. I needed something more challenging, so I set up a digital darkroom, and I got a new digital SLR on which I could use all the lenses I already owned. My first thought was to go with what I knew best—musicians—so after a couple of shakedown tests with the camera, I drove to the Delaware Valley Bluegrass Festival. As soon as I started shooting I got the buzz. I wasn't playing much bluegrass—I was deep into my classical studies with Ariana—but hearing that music, feeling the intensity of the performers, and having them give me pictures because they knew who I was and what I was up to gave me the same thrill as when I had done the photos of Bill Monroe.

Along with the camera I got a new computer, a film/slide scanner, and a photo-quality printer. I knew the process of digitizing hundreds of rolls of black and white film and thousands of slides would be time-consuming, so I had to reevaluate and prioritize my old film projects. I rediscovered my project with Monroe and put it at the top of my list. After scanning a good portion of the material into my computer I began to see that it was too good to just sit on my hard drive. I owed it to Bill to get the work out into the world. I had tried before, just after Bill passed away, and then a couple of years later. Maybe because of my lack of determination or a lack of interest in the bluegrass community, nothing came of my efforts. The time came to try again, and then . . . success!!

Although I don't have a bluegrass band now, and my musical endeavors are in another style of music, I am still drawn to the sound of bluegrass. I have always tried to be selective about the live performances I attend, no matter

the style of music. For a while I would go to any concert within a reasonable distance to be exposed to as many different performers as possible. But I often came away disappointed. When I hear a performer, I want to get a special message, I want to be moved, I want to be pinned to the back of my seat, I want to have my guts ripped out by the drive and intensity of the presentation—the way Monroe did it to me that first time I heard him in 1963. Most often that doesn't happen.

When I was learning bluegrass, there weren't many bands touring, and each had its distinctive character and sound. Reno and Smiley, the Stanley Brothers, Jimmy Martin, Jim and Jesse McReynolds, Flatt and Scruggs, the Osborne Brothers, and of course Bill Monroe—each of them were clearly and immediately identifiable. When you turned the radio on and infrequently heard a bluegrass tune, you knew right away who the band was. Now when I go to festivals, with few exceptions, all the bands fit into one of two categories: they either play songs of the old masters and try to imitate the old style of performing (too often mistaking flawed performances for replication of that sound), or they have a sterile generic sound that leaves me cold. And it's no different in the classical world of music. Early and mid-twentieth-century violinists had such unique sounds that often someone with a reasonably good ear could identify the player just by listening to the artist tune up or play one or two notes—this was certainly the case with Jascha Heifetz and Fritz Kreisler, and no less the case with Vassar Clements, Chubby Wise, or Jimmy Buchanan. There was an intimacy with the instrument, a personal touch in creating a phrase, that made the listener sit up and take notice. Too often now that is considered to be politically incorrect— those subtleties are too emotionally expressive for today's audiences.

The late, world-renowned cellist Mistislav Rostropovich once said that every phrase, no matter how joyful, should have a tear in it, that one special note of sadness that touches every listener with the humanity of the performer. Monroe understood this, maybe not intellectually, but certainly intuitively— it's obvious in his music. I hear it today in the music of only a handful of the big performers.

My mentors continue to have a profound presence in my life regardless of the distance between us in space or time. Monroe taught me to be doggedly tenacious in pursuing my vision, Bronstein showed me how to dig to my spiritual core to express myself through my love of music. Ariana Bronne has encouraged me to pour my guts into everything I play, and Mario Cabrera has taught me how to see the world around me.

When I was a college student I played five-string banjo and wanted to be in a bluegrass band. But there were so many banjo players to compete with, I decided to learn bluegrass fiddle. The general opinion at that time was that a "city" boy could learn banjo, mandolin, bass, or guitar, but if you weren't from the South, you couldn't play fiddle. So I listened to fiddlers for hours and played along with their recordings to get the hang of it, and I became the only bluegrass fiddler in the New York area at that time. Then I was asked to fill in as fiddler for Bill Monroe for a few shows in the Northeast, and he gave me a job working with him on the Grand Ole Opry. I fell in love with the instrument, left the Blue Grass Boys, and returned to the New York area, determined to learn to play classical violin. Everyone told me it was impossible to learn the violin at twenty-three years old. But I found a teacher who was willing to work with me, and six months later I was accepted into three music conservatories. In my first year of music school I had the opportunity to play for one of the most preeminent violin teachers of that time—Professor Raphael Bronstein—and he accepted me as a student. I worked with him for seven years. When I received my master's degree in performance from the Manhattan School of Music, I was already working as a freelance musician in New York. If I had listened to the pundits who told me "no" when I was a college student, I would have never gotten started. I would have conformed to family dictates and become an attorney. If I'd listened to the sages when I came back from Nashville, I'd never have given myself a shot at fulfilling a childhood dream. I would probably still be an attorney today.

Obviously, everyone does not have an equal amount of talent or physical dexterity, so my story may be unique. But Bill Monroe showed me that if I hadn't tried, I never would have known what I was capable of doing.

INDEX

GENE LOWINGER was born in New Jersey and has lived in the New York area for most of his life. After receiving a B.A. in political science from Rutgers University, he played fiddle with Bill Monroe. Lowinger returned to New York to pursue his violin studies at Mannes College of Music and Manhattan School of Music. He played in the freelance music business in New York and then worked as a systems analyst for a Wall Street bank. While working in the financial industry he studied photography at the New School and subsequently became a documentary photographer. Lowinger has had several music books published and has written numerous articles for music magazines. He has exhibited his early photography work in a number of group shows at galleries in New York. His photographs have appeared in *Strings* magazine and the *Journal of Country Music*.

The University of Illinois Press
is a founding member of the
Association of American University Presses.

Composed in 10.5/13.75 Dante MT Std
with Dante MT Std display
by Jim Proefrock
at the University of Illinois Press
Designed by Kelly Gray
Manufactured by Thomson-Shore, Inc.

University of Illinois Press
1325 South Oak Street
Champaign, IL 61820-6903
www.press.uillinois.edu